why the romantics matter

yale

university

press

new haven

and

london

peter

gay

why the

romantics

matter

"Why X Matters" and the yX logo are registered trademarks of Yale University.

Published with assistance from the Louis Stern Memorial Fund.

Yale University Press books may be purchased in quantity for educational, business, or promotional use. For information, please e-mail sales.press@yale.edu (U.S. office) or sales@yaleup.co.uk (U.K. office).

Set in Adobe Garamond type by Integrated Publishing Solutions, Grand Rapids, Michigan. Printed in the United States of America.

Gay, Peter, 1923–, author.

Why the romantics matter / Peter Gay.

pages cm — (Why x matters)

Summary: "With his usual wit and élan, esteemed historian Peter Gay enters the contentious, long-standing debates over the romantic period. Here, in this concise and inviting volume, he reformulates the definition of romanticism and provides a fresh account of the immense achievements of

Page 145 constitutes a continuation of the copyright page.

also by peter gay

Modernism: The Lure of Heresy, from Baudelaire to
 Beckett and Beyond
Savage Reprisals: Bleak House, Madame Bovary,
 Buddenbrooks
Schnitzler's Century: The Making of Middle-Class
 Culture, 1815–1914
Mozart
My German Question: Growing Up in Nazi Berlin
The Bourgeois Experience: Victoria to Freud, 5 volumes
Reading Freud: Explorations and Entertainments
The Freud Reader, edited
Freud: A Life for Our Time
A Godless Jew: Freud, Atheism, and the Making of
 Psychoanalysis
Freud for Historians

*Freud, Jews, and Other Germans: Master and Victims
 in Modernist Culture*

*Art and Act: On Causes in History—Manet, Gropius,
 Mondrian*

Historians at Work, edited, with Gerald J. Cavanaugh,
 4 volumes

Style in History

The Enlightenment: A Comprehensive Anthology, edited

Modern Europe

*The Berlin-Jewish Spirit: A Dogma in Search of Some
 Doubts*

The Columbia History of the World, edited, with John A.
 Garraty

*The Bridge of Criticism: Dialogues Among Lucian,
 Erasmus, and Voltaire on the Enlightenment—
 on History and Hope, Imagination and Reason,
 Constraint and Freedom—and on Its Meaning for
 our Time*

The`Enlightenment, an Interpretation, 2 volumes

Deism

Weimar Culture: The Outsider as Insider

Age of Enlightenment

*A Loss of Mastery: Puritan Historians in Colonial
 America*

John Locke on Education, edited

The Party of Humanity: Essays in the French Enlightenment

Voltaire's *Philosophical Dictionary,* translated

Voltaire's Politics: The Poet as Realist

*The Dilemma of Democratic Socialism: Eduard
 Bernstein's Challenge to Marx*

contents

My first lasting encounter with romanticism goes back to my days as a graduate student at Columbia University. Members of a small tribe of prospective political scientists (my department's old-fashioned, a little grandiose name then was Public Law and Government), smart, hopeful, yet almost pathologically pessimistic about our chances for advancement, we served in popular offerings, teaching basic courses in American government and, even more prominently, in a famous Columbia specialty, required for all freshmen, Introduction to Contemporary Civilization (universally known as CC). It was the core of what Columbia-trained educators praised as the presumably inimitable liberal education awaiting those fortunate enough to be admitted to the four-year intellectual banquet that was Columbia College. And in this feast, romanticism would play an unexpectedly central part.

CC was severely historicist (we liked to call it, with a touching plea for relevancy, "From Plato to NATO"), and, as its chapters traversed the centuries with mighty steps, we tried not to slight

the major epochs—the Greeks, the Romans, the Christian Middle Ages, the Renaissance, and more—that had made us what we are today. We knew—it was a cherished ingredient in our CC ideology—that accounts of the living past were open to revision, that none of the accepted interpretations was sacred. We were in fact so history-minded that we institutionalized our skepticism with weekly lunches, designed for the most part to assault our classroom certainties. And those lunches, those investigating the century and a half from around 1700 to the mid-nineteenth century, were among the most controversial. We could all agree, no matter what specialty we brought with us, that there was, say, roughly covering the eighteenth century, a powerful innovative movement called the Enlightenment, followed by a vehement cultural eruption best known as the romantic Reaction. The two, Enlightenment and romanticism, were consequential intellectual currents fully understandable only after the latter had been securely identified as a response to the former. There was, we believed, a kind of symmetry between the two that could only ease the work of teacher and student alike.

Ease it, so some doubtful participants—including me—held, too much. The summary notion of action and reaction was evidently too simple, even mechanical. There were romantics, we discovered, who did not know that they belonged to a massive act of rejection. There were enlightened *philosophes* who had as much passion for passion, praised the imagination as highly, as the most romantic of romantics. More, the very notion of a unified cluster of ideas collectively known as romanticism seemed excessive: if there were German romantics and French roman-

tics, they did not start from the same initial impulse, did not develop the same cultural expressions in their literature and their art. Would it be rational, some of us conjectured, that the only sound way to think about romanticism was to consider it as a plural which had, in the hands of great simplifiers, been shorn of its final and necessary multiplicity?

Lively as our debates were, they did not generate a wholesale revision of the CC course. But I discovered through my scholarly interests, progressively concentrating on the decades of the Enlightenment, that however plainly the romantics of any age and origin basically accepted one another's premises, each of them had his, and sometimes her, own characteristic way of thinking and speaking. Only both an individualistic and a collectivist interpretation could do justice to the assortment of ideas that we were so naïvely throwing into that single basket labeled "romanticism." Perhaps it was best to think about representative figures in these decades as members of families, with fundamental shared values and, at the same time, unique qualities. And if one could think of the eighteenth-century philosophes as a family, so one might consider the novelists and painters and critics in the romantic age as a set of families, quarrelsome perhaps but essentially expressive of some unmistakably shared features.

As through the fifties and sixties I studied and wrote extensively on the thought of the *philosophes*—the key volumes, *The Enlightenment, an Interpretation,* appeared in 1966 and 1969—I made my respect for the whole quite as urgent as my respect for individuality. And, as time went by, I repeatedly had occasion to

comment on the romantic decades, though never directly. The Enlightenment faded with the end of the eighteenth century; my cultural history of the bourgeoisie that followed it in the seventies and eighties largely started with Queen Victoria's accession to the throne in 1837, a time that coincided with my readings about the birth of modernism.[1] More or less unintentionally, romanticism had been either prelude or postscript to my work. With the present book I have finally put it into the center of my attention.

However marginal romanticism may have long been, I was naturally awake to its contentious nature; the disputed place of Rousseau in its founding, the astonishing refusal of prominent romantics like Lord Byron to accept the role of romantic; those romantics obviously progressive, even radical, in their political convictions, thus defying the notion of romanticism as necessarily a hostile response to the Enlightenment—all such crosscurrents made every attempt to define it improbable if not unthinkable. And the rapidly growing secondary literature on the subject did nothing to pacify partisans; on the contrary, as positions hardened, the warfare among interpreters grew more embittered. Since conclusions about the very nature of romanticism remained debatable, the issue of just how it mattered—the topic of this series—also remained highly uncertain.

The reading in this great scholarly contest that left the deepest impress on my mind was the text of an address delivered in December 1923 to members of the Modern Language Association by Arthur O. Lovejoy at a dinner held during the Association's annual conclave. His title was modest enough: "On the

Discrimination of Romanticisms." But the year after, Lovejoy's text appeared in the Association's official journal, thus lending it a certain immortality. The reputation of Lovejoy, a philosopher and historian of ideas who had already acquired a name with well-regarded papers on early romantics like Schiller, was impeccable. But the consequences of his address, though unfailing in courtesy and not lacking in humor, were devastating.

By quoting an extended array of passages, ranging through the ages, Lovejoy seemed to turn any attempt to produce a unitary definition of romanticism into a guaranteed failure. He explored three situations in which "romanticism" would be a characteristic definition, but each of these directly contradicted the other two. He found some amusing usages ("for Professor W. P. Ker, Romanticism was 'the fairy way of writing'") and ingeniously listed conflicting definitions of its origins back through the ages. One would "learn from M. Lassère and many others that Rousseau was the father of it, from Mr. Russell and Mr. Santayana, that the honor of paternity might plausibly be claimed by Immanuel Kant, from Mr. Seillière that its grandparents were Fénelon and Madame Guyon; from Professor Babbitt that the earliest well-documented forebear was Francis Bacon, from Mr. Gosse that it originated in the bosom of the Reverend Joseph Warton, from the late Professor Ker that 'its beginnings [were] in the seventeenth century,' or a little earlier, in such books as 'the Arcadia or the Grand Cyrus'; from Mr. J. E. G. de Montmorency that it 'was born in the eleventh century, and sprang from that sense of aspiration which runs through the Anglo-French, or rather, the Anglo-Norman Renaissance'; from Professor Grierson that St.

Paul's 'irruption into Greek religious thought and Greek prose' was an essential example of 'a romantic movement,' though 'the first great romantic' was Plato; and from Mr. Charles Whibley that the Odyssey 'is romantic in its "very texture and essence,"' and that romanticism was 'born in the Garden of Eden' and that 'the Serpent was the first romantic.'"[2]

Lovejoy took this amusing and malicious little catalogue, strengthened by related skeptical anecdotes, as evidence that "romanticism" was so crowded a collective expression that the best resolution was to abandon it altogether. But he knew his audience too well to expect anyone in the room and their fellow literary historians to accept so radical a proposal. Hence he offered his audience a more modest alternative; to substitute a plural, "romanticisms," that would be inelegant perhaps, but far more practical than the traditionally accepted term. "It is," he concluded, "with the genesis, the vicissitudes, the manifold and often dramatic interactions of [complexes of ideas] that it is the task of the historian of ideas in literature to become acquainted."[3]

I need scarcely remind you that both of Lovejoy's proposals have wholly failed to be adopted. It is, however, the second of them that I have found most useful in discussing the meanings of what is still being called "romanticism." The pages that follow should document why I have followed Lovejoy's second suggestion.

why the romantics matter

I "the re-enchantment of the world"

In 1794 Novalis met Sophie von Kühn. She was twelve, a charming, rather precocious girl, and he quickly fell in love with her. He was then twenty-one; born Friedrich von Hardenberg, he had given up his aristocratic birth name and adopted a universally accepted pseudonym: Novalis. A year later, the couple were engaged, their youthful betrothal by no means quite so unusual as it was to become. But just after her fifteenth birthday, she died. The journal Novalis kept during these shattering days records incessant, painful brooding; he was inconsolable. He made frequent pilgrimages to her grave to bring flowers and, weeping, to commune with her. Elation and

depression visited him in turn. One May evening, in the cemetery, he felt "indescribably joyful" and experienced "flashing moments of enthusiasm." Centuries were like moments; "her presence was palpable—all the time I believed she would appear." He allowed these near-hallucinations to dominate his feelings, his thoughts, his poetry for the four years that remained to him. Still, in late 1798, though he kept the candle of his cult of Sophie burning, Novalis found another young woman to be engaged to. Romantic love, with all its extravagance and inconsistency, was never more intense than in the curious tragicomedy of Novalis's infatuations. It was Novalis who summed up the romantics' case: "Love is the final purpose of world *history.*"[1]

One prominent figure of that love was its close association with death, another central element in romantic love. In his great lyrics *Hymnen an die Nacht,* one of his many tributes to Sophie, Novalis also demonstrates his determination to join her. "Life," he writes in the *Blüthenstaub* fragments he contributed to the *Athenäum,* "is the beginning of death. Life exists for the sake of death." Suicide was rarely out of his mind. "The authentic philosophical act is killing oneself," he observed in one of his unpublished thought experiments; "that is the real beginning of all philosophy."

Yet Novalis was an unusually candid diary keeper. He fully recognized that not all his thoughts on love were purely spiritual, or spiritual at all. Shortly after Sophie von Kühn's death, he candidly confided his lustful musings to his private journal: "early, sensual stirrings," or, a few days later, "sensual fantasies." Again, in May, "Lasciviousness was active from early in the day until this afternoon"; some days after: "much lasciviousness."[2]

He yearned to rejoin his fiancée's body as much as her soul, a mingling of categories typical of German romantics.

That, too, is why they kept the connection between aesthetics and theology close. In his fragment of a novel *Hyperion,* the romantic poet Friedrich Hölderlin also uses simple metaphors to establish the link. "The first child of divine beauty is art," and "the second daughter of beauty is religion. Religion is love of beauty." Surely, he went on, "without such a love of beauty, without such a religion, every state is a wizened skeleton without love and spirit, and all thinking and acting a tree without a top."[3] Hölderlin was speaking of ancient Athens, but he meant his definition of religion to apply universally. In his poems and his unfinished novel *Heinrich von Ofterdingen,* Novalis blended the spiritual and the erotic. And the last *Hymn to the Night,* titled "Longing for Death," concludes with ecstatic verse about descending to the sweet bride, to Jesus the beloved. "A dream breaks our bonds and lowers us into the father's lap."[4] Novalis's romantic fantasies were a closet drama of physical love and promised death, with a single actor on stage.

While other German romantics stopped short of allowing overt sexuality and inward piety to live in open marriage, they shared Novalis's conviction that religion is essentially a matter of feeling. Among testimonials to this literally self-centered religiosity, the Berlin preacher Friedrich Schleiermacher's *Reden über die Religion* (1799) proved the most trenchant and the most quotable. Writing to his close friend in Berlin, the beauteous and intelligent Jewish hostess Henriette Herz, who rivaled her competitors in her salon with her gift for friendship and surpassed

them with her looks, he named his faith, in a charming pun, *a heart religion—Herzreligion—*"so through and through that I have room for no other."[5]

Once Schleiermacher, still an obscure divine in Berlin, had published his stirring battle cry against unbelief, he was obscure no longer. His manifesto proved so provocative largely because it did not aim at the expected targets, the godless philosophes. Rather, he preferred to fasten on educated Germans who rarely think about God, or justify Him with arguments drawn from ethics or metaphysics. The point to be established, Schleiermacher insisted, was the autonomy of religion. It did not need sophisticated debates over the nature of the Deity, abstruse researches into proofs for His nature, or ethical speculations. True belief cannot be a collection of notions about God. In fact, those who know the most about religion are not necessarily the most pious. And modern scholasticism is simply irrelevant. The essence of religion, Schleiermacher argued—and this was the heart of his teachings—"is neither thinking nor acting, but intuition and feeling."[6] While in later life Schleiermacher would show himself a formidable scholar, theologian, and academic administrator, he never repeated the triumph of this early romantic statement. His anti-intellectualism was uncompromising.

For Schleiermacher, then, the authentic religious sense consists of a pious receptivity to love, an almost sexual opening up to God. The religious moment is a moment of ecstasy. "Modest and tender like a virginal kiss," he writes, "sacred and fruitful like a bridal embrace." Schleiermacher chose his erotic metaphors more felicitously than he knew. The "higher and divine activity"

of the human soul "flies toward that moment. I embrace it not like a shadow but like the sacred being itself. I lie on the bosom of the infinite world; I am at this moment its soul, for I feel all its forces and its infinite life like my own; at this moment it is my body, for I penetrate its muscles and its members like my own."[7]

The only religion Schleiermacher teaches is indeed religion of the heart, the contemplative surrender to, or incorporation of, the physically real divine, a seductive union of self-abasement and self-glorification that is literally amorous. As for Friedrich Schlegel, he made the same essential point by insisting on the unity achieved by a loving couple. In making love, a pair can become one. In a famous published letter to Dorothea Veit, he pleads for the natural identity of philosophy and poetry (in which he included literary prose) for the same reason.[8]

Friedrich Schlegel was truly an amazing figure. Driven by the ambition of continually expanding his grip on new experiences and alien cultures—as an adult he studied Persian and Sanskrit to improve his understanding of Asian civilizations—he was endowed with a superior gift for the quotable observation, the memorable aphorism. His life was an unpredictable series of striking shifts, which embodied his conviction that the cult of a fixed philosophical system amounts to the damaging drying up of creative impulses. Born into a cultivated family, after years of self-tormenting irresolution, he looked to a career as a classicist and made his first impression with a thoroughly informed analysis of Greek literature. But, in the first of several reversals, he soon graduated from Greco-mania to a more balanced interest in world literature, recent as much as ancient.

The career of Friedrich Schlegel amounts, somewhat like Novalis's, to a revealing exploration of romantic love. In 1797, he met Dorothea Veit, a married woman with two sons, and the daughter of Moses Mendelssohn, the most influential Jew in Prussia, a philosopher who corresponded with Kant and who pointed the way for Jews into the modern world. She was married to a Jewish merchant with no particular artistic or literary qualities. Before long, she was living with Schlegel, who admired her intellect as much as her sensuality. In 1799, he published a novel, *Lucinde,* a project he had been contemplating for several years, but which Dorothea Veit's continuous presence supplied with various realistic touches, including a scandalous account of the couple's lovemaking, which appeared particularly unacceptable because the two at times organized their coupling by experimenting with standard sexual positions. The most satisfying among these domestic adventures, the author reminds Lucinde, "the wittiest and the most beautiful, is when we exchange roles and compete with childish joy who can ape the other more effectively in this exchange [*tauschender*], whether you or I succeed better at this trading of role me acting the part of the woman while we two make love. It is thus that sexual joining makes for 'romantic love.' A fine fire streamed through my veins; what I dreamt was not merely a kiss, the embrace of your arms; it was not merely the wish, to break the tormenting sting of longing, and to cool the sweet heat in devotion; I did not long for your lips alone, or for your eyes, or for your body; but it was a romantic confusion of all these things, and a wonderful mixture of the most distinct memories and longings."[9]

In one of the famous aphorisms he published in the *Athenäum,* Friedrich Schlegel left no doubt about his contempt for ordinary bourgeois marriage. All too often, he thought, it was a matter of securing family dignity or the cool calculation of profit. "Almost all marriages are only concubinates," he wrote. They are "provisional efforts, and distant approximations toward a real marriage," an institution he defined in the romantic manner as "several persons should become just one."[10] On this important issue of man and woman's closest intimacy, he was a radical. But that was not a permanent position—very little, until his final conversion, was permanent in Schlegel. In 1804, while delivering well-attended lectures on the history of literature, he normalized his bond to Dorothea Veit: he married her. With this decisive step, he naturally involved his new wife who, in sovereign disregard for her Jewish parents, joined her husband and became a Protestant.

Nor was this the final time for Friedrich Schlegel to settle his commitments: in 1808, like other German romantics, he turned Roman Catholic, a step that soon dominated his publications, alienating his brother and other Protestants who did not approve of his latest move. This conversion was more than an aesthetic decision for him: his ample publications—he never slowed down having his lectures and essays printed—with their insistent emphasis on the sacred foundations and practical implications of Catholicism as the true religion, constituted an emphatic, wide-ranging gesture. He had entered the service of the Austrian Empire, probably the most uncompromising adversary of the French Revolution, and his impassioned defense of the Haps-

burgs mirrored his new employers' ideology. His wife, who only four years earlier had become a Christian, dutifully followed her husband into Catholicism.

Schlegel's early political publications, dating from his first efforts to translate his literary assertions into reflections on the state—in some respects his earliest romantic writings—are thoroughly progressive, even revolutionary. What the modern world needs is a universal republicanism, he wrote before 1800, a form of government that alone can provide international tranquility, which Kant had famously explored in his essay on universal peace. "The political value of a republican state is determined by the extensive and intensive quantity of truly realized community, freedom and equality."[11] Once in the service of the Hapsburgs, Schlegel never used such language again. It is part of German romanticism that its radicalism, to the extent that it survived at all, concentrated on woman's sexual liberation.

French romantics caressed their own version of love and its vicissitudes. Though their perceptions were chiefly psychological, they concentrated on their cultural implications. In the preface to Benjamin Constant's novel *Adolphe* (1816), we read that the protagonist suffers from "one of the principal moral maladies of our century." Constant meant the notorious *maladie du siècle,* which seemed to haunt sensitive Frenchmen almost exclusively. "We no longer know how to love, nor to believe, nor to desire," Constant believed.[12] And the narcissistic "hero" of *Adolphe* is a worthy representative of his conjecture.

It was not merely depression, even though depression was a widespread symptom of the sickness. It was a sense of aim-

lessness, of purposelessness, of being doomed to live without love, of being adrift on a sea of nineteenth-century men and women who could neither avoid nor escape the disease. Doubts about religion—the mental terror that German romantics had no ground to fear—were a primary sign of the ailment. Victor Hugo put it economically: the malady had grown with the introduction of Christianity "and introduced into the spirit of nations a new sentiment, unknown to the ancients and singularly developed among the moderns."[13] Considering its prevalence, Chateaubriand could wonder out loud: "It is astonishing that modern writers have not yet dreamt of painting this singular position of the soul."[14] Alfred de Vigny thought the ailment "virtually incurable, and sometimes contagious, a terrible malady that above all seizes young and ardent souls."[15] The supposed rise of nervousness, the equally widely accepted cultural neurosis that so deeply troubled the respectable in the late nineteenth century, was the legitimate heir of the *mal du siècle,* as firmly believed in and as elusive to serious researchers.

Yet despite this literary gloom, French romantics could also offer a more hopeful line of thought. At least two of them, Stendhal and Balzac, made themselves into theorists of love. Both published sensitive investigations, studies of love making it at least thinkable that some humans might be able to experience it. Stendhal wrote an impressive treatise, *De l'amour* (1820), which was in part a technical enterprise, in part a confession. From his boyhood, he had a record of frequent failure with women, beginning with his mother, with whom, he freely acknowledged, he had been in love, an infatuation his mother fully returned.

He longed to kiss her naked breasts, and "I abhorred my father when he came and interrupted our kisses."[16] This oedipal drama came to a sudden end when Stendhal was seven—his beloved mother died in childbed, and, far more often than he liked, he would repeat this traumatic love story as an adult.

In writing this informal treatise, Stendhal did his best to be objective about love, to give an "exact and scientific" account, but admitted that it was virtually impossible. "I am making every possible effort to be *dry*. I want to impose silence on my heart which believes it has a great deal to say."[17] One important thing his heart had to say to him was that women in his culture were at a grave disadvantage in love, passive victims rather than cheerful sharers. In a daring anticipation of modern feminism, he insisted that true love include esteem—Freud's argument that love must contain both tender friendship and ardent desire was far from original—and that esteem was possible only if a woman were encouraged to exercise her capacities to the full. "It offends modesty far more to go to bed with a man one has seen only twice, after pronouncing three Latin words in church, than to surrender, in spite of oneself, to a man one has adored for two years."[18] The German romantic ideal of a loving couple piously melting into a single sacred entity was quite alien to this sturdy conclusion. Sexual attraction was an indispensable element in the love that French romantics celebrated, and there was no religion in it.

One indispensable ingredient in romantic love that Stendhal particularly emphasized was the activity of the imagination. For

him the master metaphor was what he called crystallization: "At the salt mines of Salzburg, they throw the bough of a tree defoliated by the winter into the depths of the mine that has been abandoned; two or three months after, they haul it out covered with brilliant crystallizations. The smallest twigs, those no larger than a chickadee's claw, are adorned with an infinite number of diamonds, changeable and dazzling; the original branch is no longer recognizable. What I am calling crystallization is the work of the mind, which draws from everything that happens the discovery that the beloved object possesses new perfections." If the lover is particularly fortunate, the beloved he imagines will actually resemble the woman before him, but the work of fantasy makes such realistic appraisals virtually impossible, though to the lover, reality is at best a distant presence. "From the moment he loves, the wisest of men no longer sees any object *as it is*."[19] The male lover will invest his chosen object with his libido and undervalue himself. "He underrates his own good qualities and overrates the smallest favors his beloved bestows." Crystallization is a powerful source of self-deception. It lightens on the most astonishing moments. "The greatest happiness life can offer is the first pressure of the hand by the woman one loves."[20] Readers of romantic literature will recall the critical moment in Stendhal's greatest novel, *Le Rouge et le noir,* in which such a concealed hand clasp is the key to the hero's potential perdition.

To whom could such a book of recipes and reflections appeal? Stendhal leaves no doubt that he is far from having the average bourgeois in mind. The common reader is indeed too common

for such fare. After all, Stendhal consistently blamed men for the ignorance and subservience of women to men. Refusing married women the leisure that was commonplace for men—which meant time for reading—only forced women to adopt the ignorant style. Making sexual pleasure a virtual monopoly for men to enjoy could only destroy women's natural interest in such pleasure, an interest that an intelligent husband would do his best to foster. Yet this early feminism was so radical that it was to take a century and more to amount to much more than courteous gestures.

But none of this made women in the romantic age the equal of men. Those who were—and a few French woman writers like Madame de Staël and George Sand were recognized as exceptional, exempt from the limitations of ordinary womanhood—did not expand the role of most women. Stendhal's views, like those of Balzac's, notably on the character and situation of women, were glimpses of the future striking in their radicalism. In Balzac's immensely successful *Physiologie du mariage* (1829), women occupy a precarious role, as though Stendhal's assertive feminism had made no impression on Balzac. The ideals by which the middle classes lived—or professed to live—required a young woman to enter marriage a virgin, to continue respecting her family, especially her parents, never to swerve from the monogamous ideal. In several estimates of "white sheep" in France—that is of women who counted—they included women who had time and money to devote to charities and leisure. "A married woman who has her own carriage is a virtuous woman,"

but in contrast, "a woman who does her own cooking is not a virtuous woman."[21]

For English romantics, this aristocratic view was interesting but not conclusive. They were committed to another kind of love: the love of nature, chiefly as interpreted by an individual mind. This was the love that marked the *Lyrical Ballads* of 1798, the launching of romanticism in Britain by William Wordsworth and Samuel Taylor Coleridge. That is not to say that English romantics looked away from sexuality and its implications. Most important of all, they saw it in the work of romantics like Shelley and Byron. They had heard certain tales about the lives that these two poets led, even if their view was partial and their poets' conduct was to them wholly inaccessible.

Lord Byron above all made the incompatibility of bourgeois life and that of romantic poets plain. He had spent some of his young years in an incestuous relationship with his half-sister; he had, in self-imposed Mediterranean exile, delighted part of his time with homosexual adventures. And he had taken the opportunity to boast openly about his conquests to his closest friends. In 1819, while Stendhal was working on his *Physiology of Sex,* Byron reported them all to John Cam Hobhouse and Douglas Kinnaird, irritated by learning that someone had viciously gossiped about his having a "piece." "Which 'piece' does he mean?" he asked. "Since last year I have run the Gauntlet."[22] Such confessions were not meant for bourgeois readers, and would not become accessible to them for decades. Nor would they have

identified such ways of living as acceptable. That sort of things was reserved for lords and for poets.

Nor did the romantics themselves allow their imagination to blind them to the dark side of life. Death was everywhere, a grim presence for old and young alike. Medicine, no matter how sophisticated and intelligent, was largely helpless before epidemics or accidents. Melancholia was, as we have seen, the malady of the age, and there were other ailments, less distinctively modern, that made educated men and women miserable without giving them relief from calling it names. Novalis noted that what he called "original meaning" was the primal Re-Enchantment of the World state of humans drenched in religious faith, a blessed condition that the enlightened world of the impious eighteenth century had, he was certain, ungraciously, brutally, set aside. This is why Friedrich Schlegel's older brother August Wilhelm, a distinguished critic and translator and for years his brother's loyal ally, could only subscribe to Novalis's charge. "The process of depoeticization has in fact lasted long enough," he wrote; "it is high time that air, fire, water, earth, be poeticized once again."[23] His inventive phraseology was plain to his readers: to poeticize meant, in a word, to romanticize.

Depoeticization: it was the Enlightenment's sheer detestation of religion that these romantics found so unbearable. Novalis reproached the eighteenth-century spokesmen for the Enlightenment, the philosophes, with one of his most vivid metaphors: they had, he wrote, "disfigured the infinite creative music of the universe into the monotonous clatter of a gigantic mill." This

would be among the first times that defenders of the faith exploited the dread implications of the Industrial Revolution.

Intensifying this atmosphere, the philosophical German artist Philipp Otto Runge, who wrote as much as he painted, thought it a "shame how many splendid human beings have had to succumb to the miserable mentality of the so-called Enlightenment and philosophy."[24] Friedrich Schlegel would have endorsed this sentiment, for he was exemplary among the romantic rebels against the eighteenth century. Just before 1800, already widely known as a history-minded literary critic, he sought recruits for a campaign against "Enlightenment Berlinism"—*Aufklärungsberlinism*—and found them. But if Berlin was a treacherous sanctuary for piety, Paris was worse. When Schlegel visited France in 1803, one of several forays, he was fascinated by the massive cultural offerings and repelled, at the same time, by the blatant irreligiosity he saw everywhere. He called Paris "the modern Sodom," and found hearty approval among German romantics. And not just, as we shall see, among the German romantics.

The little band of German romantics took their contemptuous dismissals of modern secularism seriously. In a series of lectures delivered between 1804 and 1806, Friedrich Schlegel formally ranked the status of philosophical systems available to contemporaries by firmly placing scientific empiricism (the school of thought that the philosophes had found the most congenial) at the bottom of the pile, with materialism (to which a number of Enlightened thinkers had also committed themselves) just above it. Skepticism and pantheism, views soundly represented

among the partisans of the Enlightenment, fared only marginally better. In his hierarchy, only idealism, almost as spiritual as a religious scheme, got his full approval.

In short, religion was the foundation of German romantic thinking. Faith in God, however defined, was the source of goodwill among neighbors and peace among nations. The insanity of never-ending warfare, Novalis wrote in *Christenheit oder Europa,* would not be cured until everyone recognized that "only religion can reawaken Europe."[25] And that religion, in whatever form it might take among German romantics, could invariably count on one quality: "In its essence," wrote the poet Friedrich Hölderin, "all religion is poetic"—a curt but telling romantic summary.[26]

2.
romantic
psychology

Romanticisms had an astonish-
ing long life. Certainly painting
and sculpture, prose and poetry,
music and dance, theater and
film—fields that I have treated
and shall be touching on—show
striking resemblances, but their
arresting variety makes com-
mon ground among them seem
far-fetched and hard to establish.
No wonder a first attempt at a
comprehensive definition is likely
to be befogged and inflated by
commentators, enthusiasts, and
avid merchants of the culture in-
dustry. It has long been that way.
In truth, from the nineteenth
century through the twentieth,
"modernity" has been applied to
innovations in every domain of
high culture, to any object that

can boast a modicum of originality. Not surprisingly, historians intimidated by the chaotic, steadily evolving cultural panorama they are trying to sort out have sought refuge in a prudent plural: "modernities."

This tribute to the turbulence that pervades the modern marketplace for art, literature, architecture, and the rest, shows due respect for an imaginative individuality that has been for almost two centuries, and continues to be, the cause of spirited debates over beauty, its expressiveness, its morality and politics, in a word over the weightiest judgments of taste, and over their psychological or social origins and implications. There is something about certain prints, poems, buildings, or dramas that we classify as modern without hesitation or fear of contradiction: a lyric by Else Lasker-Schüler, a novel by Franz Kafka, a piano piece by Erik Satie, a play by Luigi Pirandello, a painting—any painting—by Pablo Picasso. Each carries its own credentials: *this,* we say, is modernity.

To the best of my knowledge, no attempt has ever been made to map all the manifestations of modernity as part of a single historic epoch. The reasons for this failure are not hard to recognize; the diverse sources of modernity in painting or fiction or musical composition are too apparent to be ignored. To paraphrase what G. K. Chesterton once said about Christianity: it is not that defining modernity has been tried and found wanting, but that it has been found difficult and not tried. Whatever cultural expressions of modernity we explore, the particular threatens to overwhelm the general. Defying these evident obstacles, this book is an essay in generalization, without slighting, let alone ignoring, the individuality of each domain.

Some years ago, Justice Potter Stewart of the U.S. Supreme Court declared that while he could not define pornography, he knew it when he saw it. Classic modern works, whatever their genre or their claim on the world's attention, leave precisely that impression. Yet for this historian of culture, the mere shock of recognition is not enough. Nor can political or religious ideologies, inviting as they look, serve to define modernity, since it is compatible with virtually every creed, including conservatism, indeed fascism; with virtually every dogma from atheism to Catholicism, history shows that moderns have bitterly fought one another over basics of belief, or unbelief.

True, they were on the whole rather less enthusiastic about the political or doctrinal middle of the road than with extremes; for all the liberalism of artists like Joyce or Matisse, moderation struck many a modern as bourgeois and boring—two epithets they were disposed to treat as synonyms. But this is not astonishing: they felt, as inveterate risk takers, most at home at the frontiers of the aesthetically acceptable, or beyond them. They took the plural of romanticism seriously; one thing that all moderns had in common—and here is the first hint at a possible escape from particularity—was the conviction that the untried is markedly superior to the familiar, the rare to the ordinary, the experimental to the routine. Yet this, it will turn out, is a great deal to be sharing. Perhaps the most illuminating metaphor we may employ as we look for larger commonalities is that of a large, interesting, far-flung family, distinct in its individual expressions but joined somehow by fundamental links.

My purpose in these pages, then, is to show that a substan-

tial amount of credible evidence, gathered across all the fields of culture I have engaged, provides unity amid variety, a single aesthetic mindset, a recognizable style—the modern style. The modern was more than a cluster of avant-garde protests; like a chord, it added up to more than the sum of its parts. It meant a fresh way of seeing society and the artist's role in it, of valuing works of culture and their makers. In short, what I am calling the modern style was a climate of thought and opinion.

For all the differences that mark off the histories of modern painting, poetry, or architecture from one another, they shared two defining attributes: the shock of the new they administered to conventional sensibilities and their commitment to a bold subjectivity. The first, the shocking innovations that offended conventional souls, is fairly easy to document. The second, a conquering, self-confident expressiveness, is harder to capture but quite as important. It was not an undisciplined acting out but an aesthetic inwardness that Knut Hamsun felicitously called "disinterested subjectivity"—the translation of feeling into art. Concentration on self-disclosure did not necessarily imply narcissism.* In modern works, inward-turning novels, abstract paintings, expressionist designs, confessional poems, and other self-exploring ventures with pen, brush, and chisel moved from eccentricity to the heart of modern cultural business.

Since this subjectivity is far less conspicuous than the moderns'

*One might speak of "good" and "bad" subjectivity, just as physicians distinguish between "good" and "bad" cholesterol in blood.

aggressive unconventionality, it deserves some brief exploration. In the age of earnest self-inspection, Victorian and after, inner freedom was the modernists' most cherished feeling. One late representative example—there are many—may speak for all: In 1940, Henri Matisse was overcome by crippling doubts about his creativity. "I am paralyzed by some element of conventionality," he wrote to his friend the fellow painter Pierre Bonnard, "that keeps me from expressing myself as I would like to do in paint."[1] He soon conquered his anxiety, but what matters here is his devotion to, and yearning for, absolute artistic autonomy, with all the guidance worth his notice emerging solely from within. And with the passage of the decades and the spread of modern art, this assertion of sovereignty came to govern the consumers of culture quite as much as its makers. The artists' willingness to speak, paint, sing freely, audaciously, "from the heart," would be matched by their publics' willingness to appreciate—and to buy—their self-revelations.

No doubt, the study of the self, far more than unconventionality, was an invention of the ancients; a search for the secrets of human nature had been conducted through the centuries by pioneers from Plato to St. Augustine, Montaigne to Shakespeare and Pascal, Rousseau (and most significantly) to the romantics, who elevated the frank exploration of the self to a core ideal. And through the centuries, bouts of earnest self-inquiry, practiced by Roman Catholics in the confessional, had been supreme efforts among countless Christians to discover how they, in their sinful humanity, stood with God.

But this pointed inquiry was designed for a particular, if press-

ing, purpose; Victorian moderns outstripped their precursors by escalating the search for the inner man—and woman—and converting it as much as possible into a dependable discipline, in a word to be objective about subjectivity.* Novelists investigated their characters' thoughts and feelings as never before. Playwrights put the subtlest psychological conflicts on the stage. Poets made esoteric departures in their disdain for traditional verse as they rehearsed the expressive possibilities of language spoken or only thought. Painting turned its back on its age-old privileged vehicle, nature, to seek nature in itself. Music in its modern guise grew for ordinary listeners less communicative than ever.

Significantly in the 1880s, Nietzsche wanted it known that the time had come once again to recognize psychology as "the queen of the sciences, for whose service and preparation other sciences exist."[2] It was a sign of how expansive nineteenth-century culture became that it moved with equal zest toward the outer world, the natural sciences, and to their subjective corollary, the sciences of mind. In fact, so powerful was the prestige of physics, chemistry, astronomy, that the scholars who on the contrary preferred to dig beneath polite surfaces to the grounds of conduct tried to make their disciplines, too, as scientific as they could. Some of the most prestigious psychologists of the age—one thinks of the great Wilhelm Wundt as the most notable exemplar—established a working environment they unembarrassedly called a laboratory.

*I should note that in this study, as in my earlier books on nineteenth-century culture, I am using "Victorian" very broadly, well beyond Britain and the United States.

In retrospect, this call to action looks like an invitation to Freud, whose ideas loom over the modern age, to make service to this royal science his mission in life. Appearances deceive: Freud, it seems, first read Nietzsche around 1900, when his elemental ideas had been in place for some time; the two pioneers, uncannily as their insights resemble one another, arrived at them independently, Nietzsche by pure intuition, Freud by the systematic introspection he called self-analysis. If Nietzsche was the philosopher of modernity, Freud was its psychologist. The distance between these two near-contemporaries has been obscured by the varied appraisal of Freud's thought, largely independent of its merits. His psychoanalytic theories have been saddled with an assortment of ancestors—not just Nietzsche, but romanticism, the kabbalah, Vienna's hypocrisy about (or, conversely, its preoccupation with) sexuality. Actually, his system emerged from his positivist's nineteenth-century confidence in science as the supreme court of appeal, which made him listen to his patients more thoroughly than physicians ever had. The couch was his laboratory. And the experience in his consulting room helped him to treat mind as part of nature that cannot escape the pressure of causality.

It followed from Freud's worldview that every mental event must yield to a secular explanation, at least in principle. The ravings of psychotics, the obsessions of neurotics, the apparent absurdity of dreams must spring from roots of which the sufferer is unaware. Hence Freud worked to uncover the irrational impulses of the human animal without joining the party of mystics or spiritualists who idealized unreason. More, he supported the

claims of his psychoanalytic inquiries to scientific stature by introducing unprecedented, but, he thought, controlled, methods of investigation. His technique of fostering free association in his patients was the equivalent of the Impressionist painter taking his easel out of doors or the modernist composer abandoning traditional key signatures. Right or wrong about the nature of human nature—and in the main, I am confident, he was right—Freud's stance embodied Hamsun's "disinterested subjectivity." His thought at once drew on, and distinctly contributed to, the modern climate of opinion.

Climates, even emotional climates, change, which is to say that modernity had a distinct history. So do romanticisms. There are initial hints of this in the late eighteenth century, the mature Enlightenment—in their animated advocacy of human autonomy Denis Diderot and Immanuel Kant might qualify as the first true moderns. Once launched, they went on to assemble most of its essential ingredients during the romantic decades in the age of the French Revolution and its aftermath. Celebrated—or notorious—romantics set a tone for defiant nonconformity. Byron and Shelley and Stendhal exhibited a certain libertinism; Friedrich Schlegel derided bourgeois marriage as a sham, and several decades later Marx and Engels charged that it was just a sordid business deal, a higher form of prostitution.

Later, modern generations carried forward the romantics' campaign against bourgeois decorum with undiminished élan. Thus the anxiety of respectable contemporaries over unconvention-

ality in painterly or dramatic practices was reinforced by their anxiety over antibourgeois ideals of conduct. Eros, at once tantalizing and terrifying, raised the banner of moral subversion, as indignant critics saw moderns defying middle-class principles and leading lives quite as irregular, at least as odious, as their work. What, after all, can you expect from artists?

By the mid-nineteenth century, the time of Baudelaire, moderns prospered with their insurgent sallies against conformist tastes, and Flaubert, in his fiction and his great letters, spurred on the artist's revolt against what he and his avant-garde friends denounced as the philistine bourgeoisie. But it was not until the 1880s that avant-gardists began to produce crops of masterpieces during some forty years of impressive effectiveness down to the 1920s. Then it began to wane in the face of overpowering obstructions, among which success proved almost as damaging as failure or persecution.

Among these phases, the four decades clustering around the turn of the twentieth century were pivotal for romanticisms in modern culture; with their historical background they deserve, and receive, appreciative space in this essay. It was a far from tranquil time: sensational, deeply unsettling stylistic shifts were disrupted by the First World War, the shaping catastrophe of our time. Its outbreak, its savagery, and its length—it dragged on from August 1914 to November 1918, with long, murderous stalemates particularly on the western front—astonished even those powers, principally the Austrians and the Germans, mainly responsible for the slaughter.

The culture wars that had agitated all the arts were, of course, as nothing compared with the casualties exacted by the real conflict. But they were startling enough: expressionist poems, abstract paintings, incomprehensible compositions, experimental plays, novels without plots were together making a revolution in taste. And after the Great War was over, modern artists went on with their revolution. Not as though nothing had happened—that would have been unthinkable; many moderns served in the war, some of them suffered breakdowns, others were killed at the front. But by and large, they took up largely where they had left off. Proust did not change his style, but introduced the war into his *À la recherche du temps perdu.* Beckmann's canvases showed a new awareness of horror and death. Postwar artists used the war as much as it used them.

In retrospect, the historian notes that this appalling breakdown in the concert of nations had a curiously uneven impact: it proved irreparable in politics, in economic relations, in optimistic attitudes, in the death of empires. But viewed against the emergence of modern barbarism, the war showed itself relatively—*relatively*—inconsequential on canvas or in print: the avant-gardes of the 1920s, innovative as they seemed, mainly harvested what the prewar years had sown, when aesthetic inventions had crowded upon one another. Each modern instance, no matter whether it dated from 1900 or 1930, confronted, fascinated, or repelled contemporaries with its astonishing little detonations, whether experienced as urbane or primitive, authentic or fraudulent, magnificent or quite simply incomprehensible. A modern poem or string

quartet was an opportunity seized, an act of aggression, a slap at what Henrik Ibsen called the compact majority.

What makes this history of modern culture particularly intriguing is that the stature of avant-garde masterworks changed across generations; often they were absorbed into the very canon their authors despised and had worked to discredit. With time, outrageous departures in the theater, the museum, or the concert hall gradually lost their power to outrage. The infuriated ballet-goers who in 1911 noisily disrupted the premiere of Nijinsky and Stravinsky's *Rites of Spring* were succeeded by audiences that found this potent amalgam of radical choreography and radical score far from subversive and really quite enjoyable. It is an apparent self-contradiction but a historical fact that modernist works, committed to providing the shock of the new by their nature, should end up being called classics.

After all, it is telling that the experiences of seeing or reading or hearing the most distinctive among modern works—Adolf Loos's Steiner house in Vienna, August Strindberg's *Dream Play,* Igor Stravinsky's *Firebird Suite,* Pablo Picasso's *Demoiselles d'Avignon* —speak with undiminished vitality to consumers of high culture today, though they all predate the First World War. Yet they are as stunning, as *modern,* as Frank Gehry's Guggenheim Museum in Bilbao, though that dates back only a few years. No matter what the chronological age of the older works, they remain pieces of the living history of culture, and give that history much of its life.

■

We may start to define modernism, then, not just as shocking breaks with tradition or the methodical quest for the self, but as an intertwining of the two. For moderns, substance and style supported each other; the "what" of innovation and the "how" of technique could coalesce. To make sense of Gauguin's yellow Christ, Joyce's unpunctuated sentences, Gropius's cantilevered corners, Duchamp's mustachioed Mona Lisa, the critic must give equal, practically simultaneous, attention to the method employed and the matter exhibited. In the words of Theodor Adorno, the content of modern art lies in its technique. Often, the novelty of modernist productions was their substance.

It was perhaps Nietzsche who most aggressively demonstrated this potent identification. A keen student of the mind in his own right, he did not merely proclaim the need to enthrone psychology in the pantheon of the sciences but also utilized it in his campaign to subvert previous thought as he turned his prose into an engine of persuasion. He once spoke of himself as philosophizing with a hammer, one of those unfortunate self-characterizations that have given him an undeserved reputation for brutality. It would have been less dramatic but more accurate if he had acknowledged that his true weapon was the pen. He piled up epigrams, aphorisms, diatribes, neologisms, lyrical verses, and rarely stooped to the philosopher's standard instrument, sustained argument.

Nietzsche's literary manner was modernity in action, as he tilted the lances of his wit, lyricism, and vehemence at the pedan-

tic, heavy technical prose of his professorial colleagues. Nor had any of his predecessors ever taken on his backbreaking agenda to cleanse contemporary thought of its deep-seated illusions about morality and religion. Plainly, he found his emphatic rhetorical techniques indispensable; he had to shout because no one was listening. Other moderns, too, broke through the accepted confines of their craft in their experiments. Cézanne, Strindberg, Joyce, Schoenberg, and other subversives flouted the hallowed rules of their game. Diaghilev is reported to have told his choreographers, "Astonish me!" It was a good modern slogan.

As the artists of the early nineteenth century rarely called themselves romantics, their heirs of midcentury and after virtually never acknowledged their romantic heritage. Actually, they began, certainly before 1900, to call themselves "moderns" and "modernists." But the historian cannot overlook their past; like the romantics, they displayed the qualities that the term "romantic" essentially displayed, above all their claim to the subjective nature of their aesthetic passions. The path to a modern romantic psychology was now open. As modernists they argued that the true source of their inspiration was purely internal. Modernist painters looked for their subject matter not in nature but in strictly private motives; modernist novelists rejected (or severely modified) the age-old ideal of mimesis, the truthful imitation of the natural world; modernist composers disregarded the equally long-lived wish for a naturalistic copying of natural sounds. Modernist painters did canvases of abstract shapes, and Piet Mondrian went so far as to declare nature to be an enemy to

art. Thus the modernist standard became a deeply private affair. Hence the romantics aim at art for art's sake—or even better, of art for artists' sake—was rarely mentioned but grew into the ideal for all artists.

There were, then, promising approaches to defining the modern, and to reviving that much neglected term romanticism. But they were sabotaged from the outset by continual, largely willful misunderstandings by one combatant of the other side—or, more accurately, of all sides—in the clashes that the moderns provoked and exacerbated. And the legends that formed around the lives of leading dissidents helped further to obscure the actual situation. Insouciant, romantic Bohemian squalor, as portrayed at mid-nineteenth century in Henry Murger's fiction (given wide circulation and unearned authority half a century later in Giacomo Puccini's opera about the joys and pains of starving for art), was more fable than fact. By midcentury, few painters or composers were still eking out a picturesque penniless existence in walkup fifth-floor garrets living in unmarried bliss—in reality, there never had been very many of them, and most avant-garde artists grew comfortable, even prosperous. Radicals became rentiers; by and large, avant-garde writers or composers of the nineteenth century, however they started out, eventually became solid citizens. The absorptive capacity of an establishment that moderns had worked so hard to subvert was nothing less than impressive.

Hence, with a few pleasant exceptions the debates among the rivals for public favor in the arts were dialogues of the deaf. All reached for what combatants in such disputes commonly turn

to: gross oversimplifications, and, with that, equally gross exaggerations of their distance from the "enemy." Fanatics at each end of the spectrum enjoyed exposing the wickedness of the other and acted on the aggressiveness that their own mythmaking permitted them to release and rationalize. The most vehement spokesmen for avant-gardes presented themselves as professional outsiders, and the establishment treated them as noisy, willful amateurs whose plays did not deserve to be performed, paintings did not deserve to be exhibited, novels did not deserve to be published. And the moderns gladly confirmed their status of pariahs by cultivating the painful pleasures of victimhood.

It follows that the historian who takes these agitated battle cries at face value is bound to perpetuate rather than expose cherished legends. It seemed all so straightforward: to established artists, critics, and audiences, moderns appeared like a united front of scofflaws or mavericks massed against the solid verities of time-honored high culture and, usually, Christian faith. Authorized spokesmen for that culture, from monarchs to museum directors, denounced these dissidents as immature or, worse, immoral, as madmen and bomb throwers. It was easy to overlook the neoromantic ambiance in which they lived.

In this inflamed atmosphere, antimodernists produced judgments notable for their vehemence, their obstinate refusal to appreciate the rebels' case. But few among the innovators alarmed their culture from the simple need to be alarming. Yet some among them worked at being offensive, and the general public obliged them by being offended. But all too often responses of the establishment were plainly out of all proportion to the

shocks that aroused them. When Ibsen's *Ghosts* was first performed in London in 1891, reviewers threw around incendiary epithets, evidently enjoying themselves as they mouthed their inflamed denunciations. Granted, the play dares to mention sexual irregularities and has a principal character collapse in an attack of syphilitic insanity. But it hardly deserved to be called a "disgusting representation," an "open drain, a loathsome sore unbandaged, a dirty act done publicly." Nor was it an instance of "gross, almost putrid indecorum" or its author "a crazy, cranky being" who was "not only consistently dirty, but deplorably dull."[3] What most strikes a later reader in these effusions is their uncontrolled hysteria, the helpless hyperbole of citizens under assault, facing—or, rather, refusing to face—hitherto repressed truths about their lives.

In short, new romantics were justified in believing that they had something important to say that established artists would not, actually could not, say. Hamsun wrote *Hunger* and succeeding fictions to remonstrate against what he condemned as the psychological superficiality of other novelists. Kandinsky gradually eliminated all references to nature in his canvases until by 1911 there were none left because he believed that all other painters had failed to capture the mystical nature of existence. Strindberg staged his early naturalistic plays, *The Father* (1887) and, a year later, *Miss Julie,* in critical response to the well-made, sexually discreet dramas then ruling the stage, and a decade later reversed the course of his modernist protest with expressionist closet dramas like *A Dream Play.* T. S. Eliot launched his provocative verse—*Prufrock and Other Observations* came out in 1917 and *The Waste Land,* that

undisputed modernist classic, in 1922—in large part because, as he put it, "the situation of poetry in 1909 and 1910 was stagnant to a degree difficult for any young poet to imagine."[4] These "moderns" had well-defended bastions of culture to assail and drastic departures to offer. For all their frivolous appearance, they knew what they were attacking. They were serious late romantics.

Candor about sexuality, always a sensitive topic and in the twentieth century still hedged about with tenacious taboos, was not the only subject susceptible to censure. When in 1905, at the Salon d'Automne in Paris, Matisse, Derain, Vlaminck, and like-minded artists exhibited their latest paintings, reviewers denounced their glowing, exuberant canvases as "pictorial aberrations" due to "color madness"; they reminded one reviewer of the "naïve sport of a child who plays with the box of colors he just got as a Christmas present."[5] The automatic dismissal of these artists, quickly but not affectionately nicknamed *Les Fauves,* "the wild beasts," became a trope in debates over high culture. Speaking of childhood: like other artists exploring their inner lives, Paul Klee saw his playful creations set aside with the condescending observation that a seven-year-old could have produced such smears. To the most determined antagonists of the new, new romantics of all stripes were an undifferentiated mass of vandals, incompetent in technique, and untalented to boot.

The most strident avant-garde oratory lent a certain color to these charges. As early as the mid-1850s the French Realist critic and novelist Edmond Duranty had advocated that the Louvre, that "catacomb," be burned to the ground, an idea that the Impressionist Camille Pissarro happily endorsed some two decades

later. The demolition of these "necropolises of art," he thought, would greatly advance the progress of painting.[6] At their most uncompromising, modernists refused to entertain any traffic with what Paul Gauguin snidely called "the putrid kiss of the École des Beaux-Arts."[7] The wish to erase the canon achieved general popularity among advanced circles. Bellicose Futurists, not unexpectedly, made it part of a larger program of aggression. "We want to demolish the museums, the libraries," exclaimed Filippo Tommaso Marinetti in his *Initial Manifesto of Futurism* of 1909, "combat moralism, feminism, and all opportunistic and utilitarian acts of cowardice."[8] Hostility could hardly go farther short of direct action.

This ferocity had enough staying power to survive the First World War. When the American photographer Man Ray landed in Paris in 1921, he was taken aback to hear such inflammatory talk in the artists' cafés he frequented: "Unfortunately when I got over here I got tied up with the avant-garde movement, which despised museums, which wanted to destroy them."[9] Yet despite all this provocative talk, strange as it seemed, modern painters and sculptors were beginning to find wall space in the very museums they wanted to set on fire.

Moderns, then, were no less heated than their opponents, no less unjust. Their principal villain was, of course, the bourgeois, Robert Louis Stevenson's "perspiring Philistine."[10] He was a figure of fun or of menace, but ridiculous or looming, modernists treated him as quite incapable of appreciating original creations. Abundant and palpable evidence to the contrary, Victorians

and later moderns lampooned the solid burgher everywhere, in plays, in novels, in poems, in cartoons, in paintings, and asked their audiences to sneer or laugh at him.

This slashing style of attack goes back to the romantic days of the modern revolution. The most consistent, most immoderate antibourgeois of the nineteenth century was no doubt Flaubert; his malicious caricature runs through his extensive correspondence and his published work like a recurrent nightmare. His bourgeois is stupid, greedy, complacent, repulsive, philistine, but, alas, all-powerful. In a much quoted letter, he called himself "bourgeoisophobus," a self-description all the more revealing for casually introducing the idea of neurotic trauma.[11] Flaubert's hatred was so fierce that it took the form of a phobia amounting to an irrational inability to see his society as it really was. His portrayal of the hated bourgeois is an indiscriminate libel that lacks all sociological specificity, and, with that, all dependable substance. Flaubert lumped together into his hate-ridden caricature working men, peasants, bankers, tradesmen, politicians, all but a select coterie of writers and artists—his friends. Uncritical reliance on testimony of this sort has distorted the history of modernity almost beyond rescue.

No one exceeded Flaubert's malice against his respectable fellow citizens, and few, like Zola, equaled him, but his tone became common coin among romantics all too prepared to anatomize the taste of those who rejected their inventions. Twentieth-century moderns could not improve on this nineteenth-century name-calling. In 1920, the Italian modern painter Mario Sironi,

soon to become the Fascists' reliable supporter, drew an illustration of a desolate cityscape in which three sinister types lurk at a corner, one armed with a pistol and a second with a knife, apparently waiting to assault a respectable-looking figure walking toward them unaware of what awaits him. The caption: "Antiborghese."[12] There is no evidence that Sironi disapproves in the slightest of the thugs prepared for their victim.

This hostility has survived into the waning days of the modern epoch; it is striking how little has changed across the decades in the moderns' hatred of the commonplace bourgeois. In 1960, the inventive avant-garde sculptor Claes Oldenburg, famous among other delightful outrages for a gigantic red-tipped lipstick erected on top of a tank,* gave the general public dubious credit for only toying with offensive novelties: "The bourgeois scheme is that they wish to be disturbed from time to time; they like that, but then they envelop you, and that little bit was over, and they are ready for the next." This despairing assessment of a recurring cultural crisis among the middle classes only underscored Oldenburg's wistful hankering for an "elevation of sensibility above bourgeois values," one that would "restore the magic inherent in the universe."[13] This is an instructive accusation: Oldenburg held with the romantics, secular and devout, more than a century and a half before him, that the middling orders had robbed the world of enchantment, which it was the supreme duty of sophisticated spirits to restore.

*This imaginative piece of sculpture is now on display in the courtyard of a residential college at Yale.

The abuse that new romantics commonly lavished on their adversaries conceals the fact that their own camp was little more unified than that of their opponents. Yet in self-critical moments some of them recognized that their vaunted individualism, which presumably freed them from the burden of history, the vulgarity of their time, and the oppression by the powerful, was easily compromised by the desire for companionship and reassurance. In the 1960s, in retrospect, Harold Rosenberg, the brilliant American critic, savagely characterized this party of heretics as "the herd of independent minds."[14] A classic cartoon in the *New Yorker* made the same point: in a painter's studio hung with incoherent abstractions a woman is berating the artist who is clearly the author of these unsalable horrors: "Must you be a nonconformist like everyone else?"

Conflicts were as typical among and within avant-gardes as their harmony. Paul Gauguin complained that the Impressionists were the slaves of visual probability; August Strindberg detested Ibsen's dramas; Piet Mondrian was disappointed that Picasso had "failed to advance" from Cubism to abstraction; Virginia Woolf had strong reservations about Joyce's fiction; Kurt Weill made scathing comments about the compositions of Erich Korngold.[15] And Salvador Dalí, as eager to astonish the public with his pronouncements as with his bizarre, often distasteful surrealist canvases, gave the back of his hand to all his modern competitors. He was destined, he told the world, "to rescue painting from the void of modern art."[16] If moderns hated and despised

the bourgeois, they could also hate and despise fellow moderns, or at least find them wanting in aesthetic discrimination.

Even more startling, from the beginning some influential moderns—not Flaubert!—tried earnestly to make peace with the tradition-minded guardians of taste. These efforts are less well known than sensational confrontations but quite as interesting. Reviewing the Paris Salon of 1846, Charles Baudelaire, a spirited, strikingly original art critic as much as the poet indispensable to the history of literature, dedicated his observations to the bourgeoisie. It was virtually supreme in his country, he wrote, and the most dependable resource for painters, poets, and composers as they founded great collections, art museums, and symphony orchestras. The bourgeois of his time were, he asserted firmly and without irony, the "natural friends of the arts."[17] At times this antimodernism had deep personal or political rather than aesthetic roots. In 1945, the important Italian "metaphysical painter" Giorgio de Chirico denounced a Cézanne landscape as "ugly, stunted, and childish," Matisse and Picasso as "pseudo painters" who had led the "decrepit and disorderly Paris School" with their "daubs and stupidities." But early in his career, before the First World War, when he made his reputation, he had strongly admired the Impressionists and Cézanne.[18] They were by no means all philistines.

More than half a century after Baudelaire and in his spirit, Guillaume Apollinaire movingly, almost pathetically, appealed to the generosity and large-mindedness of his middle-class readers. He begged them to recognize that avant-garde writers were really filled with goodwill toward their bourgeois audiences, aiming only to lead

them to hitherto unfathomed vistas of beauty and profundity: "We are not your enemies: We want to give you vast and strange domains; Where mystery in flower spreads out for those who would pluck it." And, rather astonishingly, he asked for their pity.[19]

A detailed map of modern culture, we can now see, would look as teeming, its notations as interlaced, as the Nile delta. But, as I have already suggested, if anything could unify moderns of every political stripe and aesthetic predilection, it was their struggle against what they liked to denounce as the insipid, materialistic, stifling establishment. *There* was the enemy. But what in the heat of combat and in later tranquility looked only too clear-cut—the war of the new against the old, as most history books have it—was actually an intricate pattern of skirmishes interrupted by truces and muddled by changes of front. Of all generalizations the concise "*there* is the enemy" would seem to be the most securely grounded. Certainly, to see lovers of the conventional as implacable adversaries has much to commend it. But like all sweeping statements about the history of culture, this too must make room for exceptions; at the least it requires fine-tuning.

What psychoanalysts have learned to call the narcissism of small differences, then, could move moderns to slander their allies more vehemently than they did the most benighted bourgeois. And some caught up in their own creative passions were not really interested in confrontations. Avant-garde mystics— Wassily Kandinsky comes to mind—did their work in obedience to inner monitions, to secret, inexplicable inspirations that had not the remotest relationship to the calls for better taste, or

cultural refinement, let alone political reforms that animated so many of their fellows. Typically enough, Ibsen disappointed his radical admirers when he firmly denied being a feminist.

It follows that there were prominent writers or composers whose real place was—and remains—hard to settle. Take the French novelist and literary critic Théophile Gautier, generally underrated as a skillful, essentially shallow journalist of French culture. He belongs unequivocally into the neoromantic camp: he despised the right targets, the timorous traditionalists with safe tastes; he championed the right fiction and poetry; he had a keen eye for emerging and original talents. His admiration for Baudelaire, which anticipated the general appreciation of his reputation, was near idolatry. And it reveals much about his stature among fastidious contemporaries that Flaubert considered him a friend, and Baudelaire dedicated *Les Fleurs du mal* to him as an "impeccable poet" and a "perfect magician of French literature." Johannes Brahms is another case in point. Nowadays, more than a century after his death, his music is lodged securely among the classics. In his own time, he appeared to many listeners a heavy-handed imitator of his master Schumann, whom he tried to outdo with massive scoring and unlovely melodies.* He

*Speaking of Brahms's first piano concerto, not a success in his day, one reviewer complained: "With deliberate intention, Herr Brahms has made the principal part in his concerto as uninteresting as possible; it contains no effective treatment of the instrument, no new or ingenious passages, and wherever something appears which gives promise of effect, it is immediately crushed and suffocated by a thick crust of orchestral accompaniment." *A Brahms Reader,* ed. Michael Musgrave (New Haven, 2000), 218.

was treated as an unoriginal and unruly follower of the establishment. It seemed only too obvious that if his great adversary, Richard Wagner, claimed to be writing the Music of the Future, Brahms remained mired in the music of the past.* And yet, the most discriminating listeners in his time found Brahms's compositions not just beautiful but difficult and daring—in a word, modern. It is instructive that in the 1940s, Arnold Schoenberg, the most uncompromising among modern composers, hailed Brahms as a thoroughgoing innovator.

*"In case of Brahms, exit here," the sign reportedly put up by workmen on fire doors of concert halls (the tale is credited, though not securely documented, to London, Vienna, and Moscow) supposedly protesting against his traditionalist, boring music.

3 middlemen as pedagogues

The makers and consumers of modern culture rarely confronted one another without interme- diaries. Impresarios shepherded violinists and sopranos from concert hall to concert hall, art dealers tried to convince acquisi- tive customers that they simply must own this or that of their offerings, producers of plays and operas tempted audiences with new compositions, literary and art critics expressed their opinions in as authoritative a tone as they could muster. They, and other middlemen of culture, too, inter- vened in the making of taste, re- sponding to a need of art, music, and literature lovers, many of them new to the culture market, to rise above easy entertainments

and learn to appreciate the sophisticated, the difficult, the unconventional.

There had, of course, been such intermediaries for centuries, but in the Victorian decades their influence vastly expanded. They grew into an industry. Art auctions appear as early as the sixteenth century, art dealers in the seventeenth, managers arranging concerts for composers and performers in the eighteenth, and so too reviewers of books, recitals, and exhibitions. Still, in the nineteenth century, with the spectacular new prosperity of the middle class, the public market in the arts, as distinct from commissions handed down by the aristocratic and the commanding, was transformed almost beyond recognition.

By the Victorian decades, then, these middlemen had amassed enough influence to channel—and create—demand. Around 1870, there were more than a hundred art dealers in Paris alone. Since collecting paintings presupposed the ready availability of free-floating cash, its history is irrevocably interwoven with maturing capitalism: once private citizens began to act as collectors, pictures became, more than ever, a commodity.* This commercial activity could be, and in the nineteenth century often was, a pedagogic enterprise. If any demonstration is needed of Adam Smith's famous invisible hand of capitalism—the unimpeded (and legal) activities of self-interested merchants producing unintended benefits to society—it is here: businessmen of

*But the ugly term "commodification," now so fashionable, miserably fails to convey the complexity of the transaction between dealer and buyer; it slights, really refuses to believe in, the latter's aesthetic, strictly noncommercial passion.

culture offered and sold artistic products, whether operas, drawings, or volumes of poetry, and at the same time advanced the aesthetic cultivation of the buying public. Without these aides, the modern would probably have remained the special province of a few moneyed and eccentric amateurs rather than swelling into an irresistible avalanche that would enforce fundamental changes in taste.

Much of the time, to be sure, that invisible hand of commerce in culture, far from raising the general taste, only leveled it. Art dealers, booksellers, concert managers were under pressure to give their market what it obviously wanted rather than take the trouble of breeding it up to recognize, and despise, readily digestible gratifications. Salesmen of high culture could hardly doubt that sheer diversions were easier to dispose of than complex, profound, in short, demanding work. And so, all too many entrepreneurs showed off sentimentality as emotional depth or flogged kitsch as everyone's natural favorite. They could count on a certain indolence in aesthetics on the part of their prospective customers, perfectly understandable among people not sufficiently versed in the subtleties of musical or literary composition and too tired to give them the attention they deserved.

But the easy choices that concert entrepreneurs, gallery owners, or museum directors made in their efforts to provide pleasure did not always spring from sheer cynicism. These intermediaries between producers and consumers were not necessarily men of avant-garde tastes themselves, who could sell their modern souls to exigent authorities or well-heeled parvenus. Yet they were only part of the story, since in the society in which modern art was beginning to take root, a growing segment of possible

audiences looked for progressive tuition in the arts, even—or particularly—when it contradicted the commonplaces they had grown up with. Thus cultural entrepreneurs could serve as public preceptors, much of the time for the better. One often forgotten role of the capitalist was that of educator.

Two important dealers, Knoedler in New York and Durand-Ruel in Paris, may document their convoluted share in the history of modernism. Knoedler, a family firm, was founded in 1846 and continued to expand with the years, moving more than once from its downtown Manhattan quarters to other, ever more opulent mansions. By 1895, it had opened branches first in Paris and then in London, a way of recognizing the provenance of much of its stock. Still, the house made little effort to keep up with changing tastes; the American magnates who became its regular clients—John Jacob Astor, Collis P. Huntington, J. P. Morgan, H. O. Havemeyer—strongly supported its conservative bent. For many decades, the real money was in Old Masters. If, in the 1870s, Knoedler managed to extract $16,000 from William H. Vanderbilt for a Meissonier, it charged Andrew Mellon more than a million dollars for a Raphael Madonna. The Knoedlers did not wholly slight contemporary schools—they hung the modest, attractive landscapes of the Barbizon painters on their walls, and living American artists. But for Manets, to say nothing of Cézannes, American collectors had to go elsewhere.

They had to go to Paul Durand-Ruel. That buccaneer of a merchant bought up roomsful of paintings at one time or undertook to purchase a favorite artist's complete production. His raid on Manet's studio in 1873, in which he picked up twenty-three

paintings for thirty-five thousand francs, proved immensely profitable to him, as he disposed of these treasures at from four to twenty thousand francs apiece. And his contract, dating from 1881, to buy anything that Pissarro would paint in the future gave Durand-Ruel a virtual monopoly of that modern's work, which was selling at the time for about three hundred francs a canvas but netted him ten times that and more. He was a speculator with a taste for the future. The painters, he said, whom he mainly admired—chiefly the Impressionists—"are worthy of being included in the most beautiful collections." In a world in which conformist tastes were under strong pressure but continuing to have their partisans, art dealerships could be found on every side.*

What made modern deviations from the commonplace so unpredictable was, then, that social institutions with power over the arts were often themselves unpredictable. Conspicuous among those who, we know, embraced the safe cause of salon prettiness were academies of art, beacons of conservatism in good company. From the modern perspective, this was not all bad: modernism was born in discontent and needed its spur, and discontent is precisely what gifted and energetic young artists felt in the stifling academic atmosphere, intent as they were on listening to their creative urges alone. They saw no way of saving the academy. Their solution was to create avant-garde clusters, antiacademies, which enriched and confused the cultural scene.

*It is interesting to observe that Durand-Ruel, the most radical of modernists in his taste in the arts, was, in matters of religion and politics, a strong reactionary, a good Catholic and loyal monarchist.

Another potent teaching institution in the arts, that of critic, aimed at consumers of culture more than at its producers, developed a relationship with the arts more ambiguous than those of dealers and impresarios alike. "There is a certain portion of the reading public," the *Musical Times* of London noted in 1889, "whose minds are of so invertebrate an order that they are either unwilling or unable to form an opinion for themselves. To them any statement proceeding from an authoritative source appeals with convincing force."[1] Unfortunately, too many appealing sources deserved less authority than they claimed.

Especially in mid-nineteenth-century France, as large-circulation daily newspapers acquired ever wider readership, the field of literary journalism was overrun with venal hacks whose opinions were not their own. They wrote what their editors ordered them, or the artists they covered bribed them, to write. Honoré de Balzac's depiction in *Les Illusions perdu* of a morass of unscrupulous scribblers in the Paris of the 1840s is a caricature, but only slightly overdrawn. These professional philistines spoke only to, and made more, philistines. Avant-garde artists had neither the money nor the inclination to win them over.

Corruption, though, was only a relatively minor threat to avant-garde artists compared with the incurable ignorance or inadequate cultivation among critics. In 1891, Henry James lamented the overflow of literary chatter fueled by writers utterly unqualified to pronounce on such sacred subjects as contemporary fiction or poetry, music or painting. The very multiplication of printed opinion in the Victorian age was, he wrote, summoning up his most resonant organ tones, a "catastrophe," amount-

ing to "the failure of distinction, the failure of style, the failure of knowledge, the failure of thought."[2] This was a little too grim-faced. After all, the century suffered no shortage of perceptive critics, from William Hazlitt to Bernard Shaw, including James himself. One French art critic, Théophile Thoré, was responsible for nothing less than the discovery of Jan Vermeer, among the greatest of seventeenth-century Dutch painters. And these journalists worked in brilliant professional company—producers of masterpieces who doubled in well-informed criticism—writers like Theodor Fontane and Oscar Wilde, composers like Hector Berlioz and Robert Schumann, poets like Charles Baudelaire and Théophile Gautier, painters like James McNeill Whistler and Max Liebermann. All of them, far from denying new talent or resisting change, forcefully supported both.

But the critics' erudition and sympathy, no matter how extensive or lively, gave no guarantee that they would be receptive to modern experiments. Being only human, the finest of them were partially tone-deaf in one register or another. Perhaps the most respected of literary critics whom virtually all educated French readers took as their guide, Charles Augustin Sainte-Beuve, failed to appreciate some of the fresh talent that audiences would come to greet as the first of the modern. His vigorous praise of Flaubert's *Madame Bovary* in 1857, promptly after its publication, displays his perceptive generosity toward an unconventional contemporary master. But later critics of this critic, most famously Marcel Proust, found him too much the historical and biographical judge to recognize the revolutionaries in his time. And it is true, Sainte-Beuve spoke highly of Baudelaire, but, it seems, not

highly enough, and his record on other modern outsiders is not radiant. In short, moderns fought their way partly against the critics whose goodwill they would have valued.

The nineteenth century witnessed the rise of other new men of power, museum administrators, a breed whose backing many avant-garde artists (apart from those who wanted to burn museums down) highly valued and whose opposition they judged damaging to their cause. The Victorian century was an age for the founding of museums in every civilized country, and the men chosen as directors occupied strategic posts. Strategic and exposed: they had to maneuver between boards of directors or a busybody ruler on one side and the art-loving public on the other. Hence a complex code of conduct, demanding at once flexibility and firmness, was of particular significance for them, more significant even than scholarship. They were cultural diplomats in trying posts, art collectors in the public interest and with the public's money. This meant that they had to nurture being ingratiating without showing themselves servile. And of all late-nineteenth-century museum directors, the one most strikingly equipped with such weapons was Alfred Lichtwark, who had presided over the Hamburg Kunsthalle since 1886.

In 1891, Lichtwark commissioned Max Liebermann to paint a full-length, life-size portrait of Carl Petersen, Hamburg's principal mayor, to inaugurate a new "Collection of Pictures from Hamburg." It was a risky move: Petersen, white-haired, handsome, carrying his advanced age with impressive dignity, be-

longed to the old local elite, and was not known to be a devotee of artistic experimentation. For his part, Liebermann, a native Berliner well known for his wit, by then one of his country's best-known painters, bore the stigma of being an iconoclast. That he was also a Jew did not help him in some quarters. But more important, his detractors huffed that he was a champion of ugliness in art.

Liebermann's sizable and enthusiastic clientele, which included Lichtwark, did not agree. In his choice of subjects, he was noted for crowded genre scenes—children in an Amsterdam orphanage, without pathos—and for portraits, chiefly of prominent professional men. He had honed his style under the impress of contemporary French and seventeenth-century Dutch artists— Théodore Rousseau for the first, Frans Hals for the second— whose paintings he visited and revisited on annual tours to the Netherlands and France. Two decades before the Petersen commission, Liebermann, then living in Munich, had secured widespread publicity, twice. He had painted a realistic twelve-year-old Jesus in the temple with no attempt to idealize the priests or, for that matter, the Savior, a scandalous canvas that generated an ugly debate, including harsh speeches in the Bavarian legislature. And he had sold a large painting showing peasant women in a barn plucking geese, the *Gänserupferinnen,* for three thousand marks, a substantial sum that amounted to about two years' pay for a skilled craftsman. Since then, his palette lightening, he had come close to seeing the world through Impressionist eyes.

Still, Lichtwark thought he could take a chance on Liebermann. He had met the man and liked him, visited and corre-

sponded with him, and two years before had bought one of his paintings for the Kunsthalle. A knowledgeable art historian with firm tastes, Lichtwark was the model of a museum director, a public servant who worked hard and skillfully at satisfying his directors and the museumgoing public. As Gustav Pauli, his successor, wrote about him, he "was brilliant company, and won people over by a mixture, as fortunate as it is rare, of forthrightness and discretion." He made his life, Pauli added, as though he were speaking of Oscar Wilde, "into a work of art."[3]

It is an extravagant tribute. But one can justly say that Lichtwark, by making the Kunsthalle into a school for consumers of art, put his gifts to good use, in the service of the new. In 1903, lecturing on "Museums as Educational Institutions," he made a point that moderns could only applaud: "As long as museums do not ossify, they will have to transform themselves. Every generation will offer them new tasks and demand new achievements from them."[4] Reading such thoughtful words from a museum director, an artistic revolutionary would have thought it good to keep his place intact.

That Lichtwark could gather so much power shows that hierarchical though it was, German society, certainly Hamburg's society, was porous enough to grant access to selected outsiders. The son of an impecunious miller, born in 1852 in a rural outpost of Hamburg, Lichtwark spent most of his childhood in the city conscious of his poverty and fiercely determined to escape it. His intellectual gifts, wedded to a nagging ambition, led to a career as a teacher, and then, in his late twenties, after finally attending a university and serving an apprenticeship in Berlin museums,

he made his leap into administration. His appointment to the directorship of the Kunsthalle—he was thirty-four—gratified his highest aspirations: it made him, the social outsider, into an insider. He retained his post until his death in 1914.

If anyone could have sold Hamburg's elite on Liebermann, it would have been Lichtwark. But the Petersen commission proved more problematic than he had expected. Petersen detested the portrait and denigrated it as tasteless, too casual, a mere caricature. If it was an experiment, it was an experiment gone wrong. The mayor's fellow patricians did not venture to disagree. This strong response put Lichtwark the diplomat to work. To lower the temperature of the controversy without having to give up the portrait, he kept it from being shown until 1894, and then only behind a curtain. It was not until 1905 that he dared to exhibit the portrait openly. Lichtwark, in other words, was a realist. At least he had saved a major portrait for the Kunsthalle.

He had also probably saved his job, and that mattered to him, enormously. Once a teacher, now he had a whole city and, with his publications, a whole country as his pupil. He wrote fluently and took every opportunity to put his words into print. Since he was interested in almost everything, he wrote about almost everything: interior decoration, gardens, primitive art, neglected local painters, photography, furniture, art education, even paintings. He was convinced that good taste, far from confined to poems or paintings, is a pervasive quality expressed in the house one builds, the garden one plans, the table one sets.

These excursions into the byways of taste struck him as an essential part of his pedagogic role. Contemporary Germany, he

was convinced, was sadly deficient in the finer aesthetic feelings. Nor did museums alleviate the situation. The art they now exhibited was just that: exhibition art, "an art without a home, without connections, aimed solely at the passing effect."[5] Here was a modern with a sense of tradition, in some ways the most useful ally an avant-garde could hope for, since he could speak to conservatives without a sense of alienation. The country, he wrote, and not just Hamburg, must learn to build on certain cultural habits in the arts, but, lacking them, must create them. "Without that, we will not arrive at culture."[6]

These were stark realities, Lichtwark believed, but far from being grounds for despair, they should be a call to action. To hanker for a vanished authentic high culture was to squander time and energy; only a levelheaded look at who needed to be educated, how urgently, and in what, could ever produce improvement. That is why Lichtwark spent so much valuable time observing, and reflecting about, the art-consuming public and its ways. We have already encountered his classification of that public, showing true lovers of art few in numbers and far from dominant. That lament dated from 1881. Seventeen years later, he had grown no more optimistic; if anything, the German *Bürgertum* depressed him even more. "Whoever looks at the bourgeoisie from the standpoint of art and the artist," he wrote in 1898, "will not be fond of it. A parvenu with all the disagreeable traits of the type, it is swelled-headed with its success, opinionated, arrogant, the born and sworn enemy of all artistic independence, the patron and protector of all those who flatter its vanity and its narrow outlook." Such people had no visceral appetite for art,

and had, sadly enough, succeeded in reducing architecture, the decorative arts, and painting to their own low level. A tradition-hating modern artist face to face with the buying public around the turn of the century would not have taken exception to this scathing verdict.

As Hamburg's foremost art teacher, Lichtwark's preferred forum was, naturally enough, his own Kunsthalle. Forced to confront opposition, as he often was, he would move as boldly as he could, as prudently as he must. His tastes, in part cultivated as strategies, were unusually diverse: he was a loyal son of Hamburg, a patriotic German, and a cosmopolitan modernist. This hardworking eclecticism enabled him to sponsor exhibitions of forgotten local painters (his most sustained scholarly enterprise was a bulky two-volume study of Hamburg portraitists), to rediscover virtually unknown, now highly regarded, German romantics like Philipp Otto Runge and Caspar David Friedrich, and to introduce recent French painters to German museums whom few had encountered before. He was the first director to add Courbet, Manet, Monet, Sisley, and Renoir to the Kunsthalle collection. This is what being an agent of the modern meant concretely.

Significantly, Lichtwark would buy only one, or at most two, of these avant-garde artists, compared with plenty of Liebermanns, who, though derided as an Impressionist, was at least a German Impressionist. He was opening the door a crack to the moderns, wisely refusing to flood his galleries with them, especially since most of his modern purchases were foreign—worse, French. Yet his heart was with these buccaneers who resisted the academy.

In fact, nothing pleased him more on his hunting trips for the Kunsthalle than to look at the Impressionists. In 1899, he visited their favorite dealer, Durand-Ruel, to renew cordial acquaintance with the Sisleys, Renoirs, and Pissarros on show there. This, he reported to the supervisory commission that governed the Kunsthalle, was "one of the most interesting exhibitions one can see."[7] It was free of charge, but even so there were few visitors. If we charged admission, Durand-Ruel told him, no one would come. "The public rebels against everything beautiful."[8] Apparently the French, too, needed to learn how to see; the Parisian public was only a little less conservative than its German counterpart. But not Lichtwark. Monet, he exclaimed, "always the same and always different, though sworn to a formula, always equally excellent and yet progressive." They may sneer at him and his associates, but they "will remain the great survivors."[9] He would do his part to make his prediction a reality.

That he had high-ranking colleagues in his corner could only solidify Lichtwark's taste for the new painting wherever it originated. His counterpart in Berlin, Hugo von Tschudi, director of the National Gallery there, was one ally whose combat with the old guard he watched with particular relish and some anxiety. "There is a circle in Berlin," he wrote in 1897, "whose vital interest it is to regard the famous inscription on the front of the National Gallery, 'To German Art,' as a program for its acquisitions and to allow no foreign things to enter."[10]

Tschudi's adversaries, he added, were employing two arguments in their effusions: "Patriotism and hatred of the so-called

modern—*das sogenannte Moderne.*" An unholy combination of the two was the heart of their campaign, led by the elderly Carl Schuch, specialist in landscapes and still lifes, several of whose canvases were at Lichtwark's Kunsthalle, and Anton von Werner, a German Gérôme, the leading, certainly the most highly paid, academic painter of crowded patriotic scenes—a victorious battle, the proclamation of the German Reich at Versailles in January 1871, and the like—everyone present painstakingly drawn and instantly recognizable. "For us," Lichtwark told the administrative committee, "this quarrel is of direct interest because Werner and Schuch, using Hamburg's reactionaries, are trying to sow weeds among our wheat. Werner's and Schuch's pamphlets are being distributed in Hamburg by the hundreds."[11] Aggressive avant-garde artists were not alone in those years to take up arms.

Words were not the only weapon. Money was quite as effective, often more so. In the quarter-century that Lichtwark presided over the Kunsthalle, it had become a routine lament among museum administrators that invading collectors from the United States, spendthrift and voracious, were raising prices not just for Rembrandts and other Old Masters, but for modern art no less. True, perhaps, but European museum directors were quite as greedy in the competition for first-rate work as any American. Granted, they could not arbitrarily exceed their annual budgets to snag a particularly desirable—and expensive—canvas, but they could shift proportions within their subventions, or beg particular financial backing for special acquisitions. Lichtwark commissioning Liebermann to do the portrait of Bürgermeister Petersen could never have been financed without a private subsidy.

And so when it came to advancing the fame (and elevating the price) of controversial moderns, European museum directors were the Americans' most assiduous rivals. In 1912, Lichtwark was, as so often, in Paris, and bought a splendidly animated Renoir, rare in his oeuvre, an elegant young Parisienne on horseback in full riding habit accompanied by a boy on a pony—for just ninety thousand marks. In retrospect, the three thousand marks that Liebermann had gotten for his *Gänserupferinnen* forty years earlier—there was relatively little inflation in those times—becomes a real bargain. And this is how bureaucrats with a taste for the new and the tenacity to enforce their choices joined other middlemen-pedagogues to function as agents in making modern art a viable alternative to traditional tastes in the battlefield of nineteenth-century high culture.

4 art for artists' sake

By 1867, the year of Baudelaire's death—Queen Victoria had been on the throne for thirty years—playwrights, architects, composers, poets, novelists, and other makers of high culture who yearned for social respectability had largely acquired what their forebears had long struggled for. There were still patches of ground, especially in central and eastern Europe, where artists had not yet wholly cast off the status of servant. But in western Europe and the United States, they could make friends with, and marry into, the upper middle classes or the gentry, and make grand claims for the autonomy and the dignity of their vocation.

Their cause could only prosper

from the spectacle of aristocrats like Lord Byron or the Vicomte de Chateaubriand, who did not disdain writing poems or novels, and even getting paid for it. Even a few German states timidly joined this status revolution: Goethe and Schiller were raised to the nobility. That von Goethe was also a hardworking public servant and von Schiller a university professor did not exactly injure their social transfigurations. But their sober occupations were not the main reason for their elevation, which they largely owed to their literary fame.

The elbow room that aspiring avant-garde artists, like their more conventional colleagues, needed was more than mere celebrity. What they craved was an ideology, a solid validation of their lofty modern status. In 1835, with the publication of Théophile Gautier's naughty *Mademoiselle de Maupin,* this rationalization made an impressive stride. Gautier, all of twenty-three, prefaced the novel with a long racy manifesto, which championed what would come to be called, tersely, art for art's sake. In view of its historic import, it should really be called "art for artists' sake," for it was a declaration of independence for the maker of beautiful objects as much as an appreciation of the objects themselves. It rejected the classic division between the two, which had separated art (highly admired) from the artist (socially disdained).

Art, so this modern doctrine went, serves no one but itself, not mammon, not God, not country, not bourgeois self-glorification, certainly not moral progress. It boasts its own techniques and standards, its own ideals and gratifications. "I don't know

who said it, I don't know where," Gautier wrote, "that literature and the arts influence morality. Whoever he was, he was doubtless a great fool." All that the arts produce is beauty, and "nothing that is beautiful is indispensable to life." The good looks of women, the charms of music and painting, are valuable to the extent that they are useless. "Nothing is truly beautiful but what can never be of use to anything. Everything that is useful is ugly, for it is the expression of some need, and human needs are ignoble and disgusting, like men's own poor and feeble nature. The most useful place in a home is the latrine."[1] Nothing could be plainer.

Art for art's sake was in fact too direct a proposition for many advanced writers or painters to support it wholeheartedly. And yet—which is why the doctrine had broader impact than its limited explicit support would have indicated—antibourgeois, antiacademic artists were only too pleased to exploit its implications without fully subscribing to its principles. Cultural pessimists all the way back to Plato had believed that the wrong kind of poetry or the wrong kind of music has pernicious effects on morals; at the other extreme, believers in the innate goodness of human nature found it hard to abandon the hope that the right kind of poetry or music would purify conduct. Many modern heretics retained some of the old faith that painting, the drama, the novel have a moral mission. Whichever side an artist was on—for every Joyce or Schoenberg, creating for its own sake, there was a Strindberg or an Eliot working under the pressure of powerful social and religious convictions. In effect, art for art's

sake was a radical assertion in behalf of nineteenth-century artworks, as well as of their makers' claim to sovereignty: the artist is responsible to no one but himself, and herself, except perhaps to other artists. Anxious conservatives reviled this lofty self-appraisal as a typical symptom of modern arrogance.* Yet this is what England's most influential aesthete, Walter Pater, one of Oscar Wilde's intellectual forebears, essentially meant with his famous declaration, "All art constantly aspires toward the condition of music"—the purpose of art is art. This, too, is what the young Algernon Swinburne, still an untamed devotee of dissident French poetry, meant when he defended his first volume of verse, widely disparaged as immoral, by insisting that he had written his *Poems and Ballads* (1874) as "adult art" with a purity of its own. "All things are good in its sight." Whether his verses could be "read by her mother to a young girl" or not was perfectly irrelevant. In short, it did not take much for the cult of art to blossom into the cult of the artist. This is the cult—the cult of himself—that James McNeill Whistler, the most barbed

*In 1895, in an article of *Die Grenzboten,* a highly respectable German periodical with strongly conservative leanings, the author deplored "the claims of the modern school," which has "the creative artist simply stand above the domain of theoretical art criticism. The artist marches ahead, creatively, he places the new before us; should the public not understand him, should what he has created fail to fit into the aesthetic clichés of the critics, still they must follow him. . . . Some day they will be able to judge his work. That, by and large, are the empty phrases one hears from this direction, and which are supposed to dispose not merely of the public with its mere 'layman's judgment,' but the trained aesthetician as well." Anon., "Spiritual Contents in Painting."

and most gifted spokesman for the aesthetic movement, rated in his lectures and his bon mots.

One can trace this development in modern manifestos. A most articulate instance came from the declarations of self-proclaimed progressive Belgian painters who in late 1871, after five years of working closely together, published the journal *L'Art libre,* complete with a "Profession of Faith." It told the world that they were their country's cultural avant-garde who represented "new art," with its "absolute freedom from directions and tendencies, its character of modernity." Defying "reactionary coalitions," it sought to assure the victory of "Modern Art" by battling the forces that would try to stop it, turn it aside, or slow it down. "We want free Art. That is why we fight to the death those who want it enslaved." In its second number, *L'Art libre* followed up this jaunty declaration of war with a solemn agenda. "Today, artists are, as they have almost always been, divided into two parties: conservatives at any price, and those who think that Art can survive only on condition of transforming itself. The first condemns the second in the name of the exclusive cult of tradition."[2] The identification of modern artists with the hallowed cause of Art can hardly be closer than this.

By this time, as it was fading in reality, the pathetic figure of the artist and his bitter struggles with poverty and neglect remained a familiar protagonist in fiction. In the literary imagination, he was always the outsider, always the victim of the philistine present and the prophet of a less commerce-ridden future. Balzac's *Le Chef d'oeuvre inconnu,* the model for others, with its artist doomed never to finish his masterpiece, dates back to 1831.

One of its offspring, *Manette Salomon* of 1867, was the Goncourt brothers' contribution to this genre; it follows the fate of artists, two of whom seek only the truth of the modern. But both necessarily fail; society is too strong, too vulgar for them to realize their ideal. One is compromised by his inability to sustain the necessary quasi-religious asceticism—that is, the authentic religion of art—the other destroyed by his infatuation with an insatiable, vicious Jewish model. Both clearly perceive that "traditions, the ancients, are the stones of the past lying heavily on our stomach,"[3] and that the artist must shake them off by nourishing his hostility to bourgeois society, which cannot tell a slick production from an authentic work of art. Bourgeois society, *Manette Salomon* tries to document, has a way of subverting the authentic by the meretricious—and that pressure makes for suspense in this mediocre, tendentious novel, even though it is more an expression of self-pity than a telling diagnosis of a threatening cultural malaise.

The seedbed for the principle of art for art's sake had been planted decades before the emergence of modernism with the idealization of selected monuments in the world of literature, painting, and music. While the glorification of artists' lives was anything but new—one thinks of Vasari's biographies of Renaissance painters, to go back no farther—it assumed downright worshipful forms during the romantic decades, at least for outsized celebrities like Goethe and Beethoven. These two, in vivid contrast to lesser fellow artists, who were mere mortals, were

canonized as secular saints whose possessions adorers treated like relics.* This pious vocabulary is worth noting.

Beethoven let posterity take care of his image. Not Goethe: if he became a legendary figure, he was in large part the maker of his own myth. He was distinguished and long-lived, dying in 1832 at the age of eighty-two. He carried on a large and enlightening correspondence, explained himself in detail in his autobiographical writings, permitted—in fact invited—readers to draw biographical inferences from his voluminous poetry and prose, and gladly received visitors who faithfully recorded his sage pronouncements. The most faithful of these, Karl Eckermann, Goethe's Boswell, published his conversations with the Master in two separate volumes in 1836 and in 1847, which both interestingly enough became, and remained, best-sellers.

This devout attitude, though it did not remain uncontested, survived through the nineteenth century and beyond, and produced its share of clichés. It had its undignified moments, like the adulation of, and intrusive curiosity about, dazzling idols like the violin virtuoso Paganini, adding up to a high form of

*In 1855, Eduard Hanslick, on his way to becoming "czar" of music reviewing in Vienna, a man who prided himself on his independence and his freedom from sentimentality, visited Weimar to see the houses of Goethe and Schiller. The latter was "generally accessible," and "thousands had been moved and edified as in a church." In Goethe's mansion, only the rooms housing Goethe's collections, his plaster casts and minerals, were open to the public. Though offended by this "insulting aristocratic contrast," Hanslick approved of the care with which the Master's "precious relics" had been preserved.

gossip. But the spiritual tone of voice thought proper for literary and musical geniuses was more serious—and more consequential. So intelligent a critic and professional a musician as Robert Schumann did not hesitate to celebrate Beethoven as a "high priest" officiating "at the high altar of art." Only Wagner went him one better: in his essay, "Pilgrimage to Beethoven," he observed that Beethoven's music was a guarantee that "my redeemer liveth,"[4] and left no doubt that his contemporary redeemer was indeed Beethoven. These were early stations on the road to the sanctification of artists; in its distorted, almost childish simplicity it laid the groundwork for the modern self-confidence immensely helpful to its success.

The cult of art so easily turned into the cult of the artist because that spiritual vocabulary—"high priest" or even "redeemer"—became so commonplace among nineteenth-century artists and their admirers. In that increasingly post-Christian age, the sheen of unconditional devotion to higher things had not yet lost its luster. At the end of the eighteenth century, William Blake had pronounced that "Christianity is Art,"[5] and set it off against the worship of money.

Half a century later, Arthur Schopenhauer gave such talk intellectual respectability, and in the 1890s, the popular German poet and playwright Richard Dehmel, to give but one instance, spoke for a tribe of new believers when he told a friend, bluntly, "My Art is my religion."[6] In these years the French critic Camille Mauclair wrote a book titled *The Religion of Music*. And in 1909, Shaw, in his play *The Doctor's Dilemma,* has the amoral artist

Louis Dubedat pronounce his blasphemous creed on his death-bed: "I believe in Michael Angelo, Velasquez, and Rembrandt, in the might of design, the mystery of color, the redemption of all things by Beauty everlasting, and the message of Art that has made these hands blessed. Amen. Amen."[7] Shaw took care to capitalize Beauty and Art, as Flaubert had done half a century before him; no doubt, Art had become, at least for some, a new religion, a substitute for a fading Christian faith.

But the religion of art cannot claim to have been very successful; its rhetoric was too obviously empty and forced. Yet it retained partisans beyond the First World War. In 1920, the well-known Italian art critic and cultural commentator Margherita Sarfatti, for years Mussolini's mistress, turned back to the old romantic fantasy. "Life imitates art," she wrote in the Fascist newspaper *Il Popolo d'Italia;* "artists are the spiritual guides who determine unawares the future attitudes of the general populace."[8] The dream of the artist's omnipotence died hard.

The advanced circles that backed art for art's sake were small but enthusiastic and eloquent. By the second half of the nineteenth century, the phrase had become a favorite slogan among aesthetes, often as recognizable by their dress as by their opinions. Among their most conspicuous representatives, some of them—notably Gautier, Swinburne, Huysmans, Whistler, Baudelaire, and Wilde—often almost literally wore their aestheticism on their sleeve. But to take this fashionable service to self-display as defining Wilde, probably the most extravagant of them, is to trivial-

ize his magnitude as a cultural icon. With all his lightheartedness, as we shall see, he ended up a martyr to the religion of art.

Wilde founded no school, nor could he have done so; there could never have been a second Oscar. "The only schools worthy of founding," he once said, "are schools without disciples."[9] His originality faced in two directions: he surpassed his followers no less than his ancestors. When he worked within a tradition, as with his dramas, he emancipated himself at the end to produce a masterpiece, *The Importance of Being Earnest,* that only he could have written. When he proclaimed, and practiced, art for art's sake, he developed a version of the doctrine that its originators would have found extravagant; he placed the critic even higher in his hierarchy of creative spirits than the artist whose work he criticizes. William Butler Yeats, who came to know Wilde in the late 1880s, called him "a man of action, exaggerating, for the sake of immediate effect, every trick learned from his masters."[10] That is a little harsher than it need be, but it is true that for the sake of being up-to-date, Wilde, ever militant, took his persuasion beyond the dreams of Gautier or Baudelaire. He was fated to become a belated romantic who never applied this characterization to himself, with his adoration of beauty in defiance of accepted rules of literature, his partly explicit contempt for the middle classes, his defiant designs for innovation. Romanticisms had been through the years varied enough to accommodate an original like Wilde, only wittier than his ancestors.

Oscar Wilde was born in Dublin in 1854 to well-connected Protestant middle-class parents—his father an eminent eye specialist,

his mother a voluble poet and quite as fervent an Irish patriot as her husband. He shone at Magdalen College, Oxford, sporting a rare double first, celebrated for his repartee in the common room and the exquisite china in his flat. He was already an aesthete, and never changed. Even his political ideology, an idiosyncratic anarchistic socialism, was an outgrowth of his aestheticism: the abolition of private property and the family would create, he argued, a "true, beautiful, healthy Individualism."[11] He enchanted (though at times also put off) attentive audiences in Britain and the United States with well-constructed lectures on the decorative arts and practical household hints. His life's mission, he declared, was to make the world love beauty. Modernism had no campaigners more amusing in their propaganda work than Oscar Wilde.

He prospered in private life no less. In 1882 he acquired (all accounts agree) a pretty, intelligent, well-read, and devoted wife. He charmed parties with his quick wordplay and quotable pronouncements. In the years that followed he won his credentials as a controversialist with astute and forceful book reviews and combative essays on literary criticism. Even though some suspicious readers of *The Picture of Dorian Gray* (1891) found disturbing symptoms of perversity, they took this dark, widely talked-about tale seriously. And even after his disgrace in 1895, when he ended up in Her Majesty's prisons as number C.3.3., he could count on a few—a very few—sympathetic friends. He died in Paris in 1900, remaining an aesthete to his last curtain call, traces of his mordant humor intact to the end. He told one of his last visitors, "My wallpaper and I are fighting a duel to

the death. One or the other has to go."[12] Predictably, he lost that bout, though he was also, poignantly, a victor, transfiguring his cherished aesthetic ideal into life for art's sake.

Wilde's life was a persistent skirmish with the party of conformity. His much-admired wit attests to his utter seditiousness. More than a device for capturing or retaining the attention of his audiences with his "fluent paradoxes," in James Joyce's words, it was his preferred way of demonstrating that what most of his contemporaries thought profound and true was shallow and false. Wilde's wit is hard to imitate but easy to analyze. Again and again, he would take an accepted truth, a cliché or a commonplace, and reverse it. One instance, the most-quoted Wildean epigram of them all, may suffice. It was reported by Ada Leverson, one of his steadfast supporters during his time of trials. Speaking of the way that Dickens handled Little Nell's demise in *The Old Curiosity Shop,* he told her, "One must have a heart of stone to read the death of Little Nell without laughing,"[13] at once ridiculing the truism to which virtually every reader of Dickens, all too ready for tears, would have subscribed and offering an aesthetic alternative.*

*In a memorable passage in praise of the imagination, Wilde built his case with a sequence of outrageous paradoxes. "Many a young man starts in life with a natural gift for exaggeration which, if nurtured in congenial and sympathetic surroundings, or by the imitation of the best modes, might grow into something really great and wonderful. But, as a rule he comes to nothing." For, Wilde continues, "he either falls into careless habits of accuracy, or takes to frequenting the soci-

No doubt, Wilde's epigrams could be too slight or too strenuous to do his critical work effectively. But his quip about the death of Little Nell is not just funny; it raises in a single sentence interesting questions about the sociology and history of taste and about the relation of a writer to both. No wonder that George Bernard Shaw should have called Wilde "Nietzschean"—Nietzsche, too, could be dazzling in his sayings, and, like Wilde, skeptical about the permanence of claims to truthfulness. Both, each in his way, were energetic immoralists, hence both lived in precarious circumstances.

At times, more alert to his antagonistic milieu than most fellow moderns, Wilde showed himself aware of the risks he was taking. In 1886, almost a decade before his catastrophe, he famously likened the artist's life to a "long and lovely suicide,"[14] and professed not to be sorry that it should be so. One now reads these words, with their appealing mixture of casualness and solemnity, as remarkably prescient. Yet on the surface, at least until the spring of 1895, Wilde's life seemed charmed if not exactly placid, a succession of triumphs scarcely marred by a few setbacks. As early as 1881, in *Patience*, Gilbert and Sullivan had exploited him as a celebrity worth lampooning, having not just

ety of the aged and well-informed. Both things are equally fatal to his imagination, as indeed they would be fatal to the imagination of anybody, and in a short time he develops a morbid and unhealthy faculty of truth-telling, begins to verify all statements made in his presence, has no hesitation in contradicting people who are much younger than himself, and often ends by writing novels which are so life like that no one can possibly believe in their probability."

one but both male protagonists impersonate him. Such gentle spoofs served to protect him, for a while. By this time, cartoonists were turning him into a distinctive target for thousands of newspaper and periodical readers in the United States almost as much as in Britain, with his eccentric suits, extravagant neckties, and languid pose clutching a lily or leaning against a sunflower. He spent valuable hours and exquisite care on his appearance, his speech, his instructions to his barber, his presentations of self on private and public occasions. "To become a work of art," he once wrote, "is the object of living,"[15] and he certainly believed that he was sincerely pursuing that agenda. One Christmas, when Wilde and his family were living in a small house in Chelsea, Yeats was invited to dinner, and later recorded, "I remember thinking that the perfect harmony of his life there, with his beautiful wife and his two young children, suggested some deliberate artistic composition."[16] No wonder he made excellent copy, more serviceable than more humorless fellow avant-garde writers. And except for the end, he did not object to the publicity. It kept him in the news, which was where a dandy, a work of art for art's sake, clearly belongs.

But there came a time, during his months in court, when the public attention he had sought became a plague to him. Wilde's trials have been exhaustively reported, but their place in the history of modern art deserves further exploration. He was—we recall Yeats's impression of perfect domestic harmony—to all appearances a happy family man. But in 1886, he allowed a young student, Robert Ross, to seduce him, and from then on, homo-

sexual themes pervaded Wilde's friendships, his travels, even, though more subtly, his writings. It was as though, after embracing the dangerous dogma of art for art's sake, he took on a second burden: the love that dared not speak its name. In 1891, already committed to that criminal love, he met Lord Alfred Douglas, who was to coin this famous definition of same-sex infatuation a year later. And so love, romantic love, fatally entered his life.

Wilde's discovery, "Bosie," was sixteen years younger than the writer who became his lover and his victim, blond, pallid, slight, a very minor poet, extremely moody and demanding. He could be charming when he wanted to be. Unfortunately for Wilde, though, he did not want to be charming most of the time, but quarrelsome and vicious, utterly self-absorbed, capricious, unscrupulous about cadging money from Wilde. But Wilde, though at times compelled to protest Bosie's cruel whims, was helplessly in love; he took Douglas on trips and paid and paid, financially and emotionally.

While in those years, homosexuality was draped in euphemisms like "Greek love"—the technical term itself had been coined as recently as 1869—the century made a large issue of it. Scientific research into its origins and nature, or special pleading masquerading as scientific research, became a common pursuit. Until a fanatic for truth like André Gide came along, it was practiced clandestinely, and religious believers exploited it, or rumors about it, as a stick to beat the avant-garde with, as though there were something effeminate about new music, new poetry, new theater. Newly founded empires—Italy in 1870, its German counterpart in 1871—introduced legal codes as other

countries revised old ones, and some states decriminalized homosexual congress between consenting partners, while others, like France, which had erased it from the criminal code during the Revolution, had never turned its back on that progressive act. But in 1885, carefully calibrating punishment in accord with the gravity of the offense, Wilde's Britain toughened its penalties. A judge could impose a life term for sodomy. On that score at least, Wilde would be lucky: the charges against him were comparatively minor "acts of gross indecency."

Douglas dragged his famous lover through ferocious quarrels, but Wilde refused to send his "gold-haired angel" packing. Only too willingly, he let Douglas introduce him to a life of debauchery. Each of them took his pleasure freely with others, increasingly with youngsters who made love for money. With every new partner, the risk of blackmail mounted, but Wilde found the ready availability of beautiful boys, whether in London or in Algiers, irresistible. Then, in February 1895, Douglas's father, the marquess of Queensberry, on bad terms with Bosie and fiercely opposed to his attachment to Wilde, left a scribbled note at Wilde's club, "To Oscar Wilde, posing Somdomite."[17] Wilde, not amused by the misspelling and failing to note the escape hatch that "posing" would give the explosive nobleman, imprudently sued him for libel.

Inevitably he lost his suit; the image of a concerned father eager to shield his son from iniquity, and evidence that Wilde had indulged in unsavory assignations, carried the day for Queensberry. And, since the names of prominent politicians had

been introduced, the authorities felt obliged to prosecute Wilde instead. His first trial ended in a hung jury, but in a second trial, in late May, his peers found him guilty as charged. He was sentenced to two years of hard labor. With rude suddenness, in the space of four months, Wilde was cut down from being London's lionized playwright to being a stigmatized criminal. The two hits he had running simultaneously were promptly taken off the stage, while Wilde was hustled to prison, an experience that nearly killed him. The religion of art, as I have already hinted, had its martyrs.

Why did Wilde not escape abroad, as he had ample opportunities of doing after his first trial? Literary historians and biographers have puzzled over the question for a century. Most sympathizers, including Shaw, the Leversons, and his wife urged him to seek safety abroad. Sadly, a little angrily, he turned them down. The reasons for his course of action—or inaction—were complicated: Bosie, intent on injuring his father publicly and ready to sacrifice Wilde to his own oedipal fury, would not hear of it. Nor would his mother, in misplaced maternal pride. And it is plausible that he was driven by a largely unconscious desire for punishment, seeking out a long but far from lovely suicide. But there was another probable motive: Wilde's self-image as a heroic witness for the kind of cultural elite that the vulgar always fail to understand and never fail to persecute.

The larger meaning of the Wilde case, then, lies in its bearing on the history of modern art. His trials did more damage to the defendant than had their prosecutions to Flaubert and Baudelaire. And it is a far cry from the Nazis' exhibiting "degenerate

art" across Germany in 1937 as a matter of state policy. But it remains a traumatic moment. The view among a solid majority of commentators has long been that the principal instigator and beneficiary of Wilde's conviction was the prudish, insipid, resentful middle-class public, impatient to disgorge its rage against a self-proclaimed culture hero who had snobbishly sneered at the morals and the tastes of ordinary citizens.* In his authoritative biography of Wilde, Richard Ellmann speaks for a consensus: as the trials were about to start, "Victorianism was ready to pounce."[18]

Why? No doubt, Wilde had been provocative; he had made enemies, particularly among literary men who had smarted under the lash of his reviews. He had irritated others with his self-confident pronouncements, with his addiction to paradox, his flaunting what others were doing on the sly. There had been deep, unspoken anxiety among many who had watched Wilde in public; the apostle of pleasure had questioned their character, and now, a convicted felon, he had involuntarily vindicated it. But there was even more to it than this: the sheer offensiveness of his art-as-religion enterprise. The response of the English press is revealing. Most respectable newspapers like the *Manchester Guardian* gave the trials only modest coverage. Other

*This is not a new opinion. The young Ernest Newman, years before he amassed an enviable reputation as a music critic, wrote that Mr. Justice Wells's denunciation of the degenerate defendant had been "the bovine rage of the Philistine." This resounding slap at pious, hypocritical England was particularly notable because it appeared in print only a week after the trial ended.

high-quality dailies like the *Pall Mall Gazette* and the *Times* of London treated the affair as newsworthy and entertaining, quoting from the attorneys' speeches, the defendant's testimony, and the judges' comments, but studiously refrained from moralizing, refusing to feed their readers' self-righteousness.

And, significantly, those newspapers that did welcome the chance to sermonize—by no means the majority—placed Wilde's debacle in moral and cultural terms. The *St. James's Gazette,* which approved of the stern sentence meted out to the "perverted criminal," saw it as a necessary reproof to Wilde's ethical relativism, to the "New Tolerance" that had been poisoning "our art, our literature, our society, our view of things."[19] The newspaper saw the proliferation of styles in novels and paintings and the experimental attitude toward subject matter as a direct offspring of Wilde's libertinism. He was dangerous less because of his tainted loves than because of the intermingling of his erotic tastes with his "religious" advocacy of art for art's sake. Perhaps still more appalling, ran this analysis, the coexistence and collusion of these two "perversions" had served as a foundation for Wilde's haughtiness as an artist, permitting him to feel superior to ordinary mortals.

What mainly brought him down, then, was Wilde's arch-heterodox assertion in the preface to *The Picture of Dorian Gray* that "there is no such thing as a moral or an immoral book. Books are well written or badly written," a shocking statement he acknowledged as his view on art in his libel suit against Bosie's father.[20] His martyrdom is inseparable from his enthusiasm for what the *Westminster Gazette* called the "unwholesome tendencies" in art

and literature he practiced and encouraged. Except for their libertarian impulse to commend laissez-faire in such private matters, avant-garde artists had no general position on acceptable sexual behavior. Nor did homosexuals or lesbians dominate these circles. It is easy to compile a list of them—Rimbaud, Verlaine, Proust, Gide—but their sexual tastes did not define their cultural epoch. What mattered most in the Wilde case was his insistence that life and literature are two things apart, and that trying to improve the morals of the public through novels, plays, and poems is inartistic and a sheer waste of time.

I have called Oscar Wilde (in Nietzsche's company) an heir to the romantics. He was certainly along the line of romantics like Shelley and Byron; indifferent, even hostile, to bourgeois morality and enamored of the arts. One can easily visualize him as a member of an antimoralistic band of artists exhibiting his love of beauty and his contempt for a doctrine that will tie literature, indeed all the arts, directly to life; to couple the pair, the arts and life, with joint authority in the areas of manners and, more significantly, ethics and general morality. There were other such nineteenth-century heirs like Baudelaire or Rimbaud, who would, like Wilde, speak for a minority of voices clamoring for an independent voice that would defy common morality and concentrate on making the cult of beauty central.

This is the place to enlist the Oedipus complex to assist in visualizing and, in part, explaining these knotty complications. The intergenerational triangle was, of course, not unique to the age of Freud, but ancient as much as modern. But his naming

the phenomenon after a tragedy by Sophocles was not just a literary conceit on the part of an educated Victorian. The increasingly liberal nineteenth century, with its enlarged tolerance and the widespread distaste for zealotry, provided unparalleled room for minority views and unconventional tastes in religion, politics, and the arts—especially in their civilized sublimated manifestations. The first man who threw an epithet at an enemy instead of a spear, Freud wrote in the early 1890s, was the founder of civilization, and the nineteenth and the early twentieth centuries pushed this humane self-discipline to new heights. Which is to say that the Oedipus complex, as Freud, its discoverer, was also the first to observe, had a history of its own. Strictly speaking, Freud was not the first to recognize this complex. Among his precursors was Denis Diderot (whom Freud happily quotes). What Freud accomplished was to make it a central part of his psychoanalytic theorizing.

Freud, then, though not a professional historian, had a historian's mindset. Comparing the working of the complex in Sophocles' *Oedipus Rex* with that in Shakespeare's *Hamlet,* he demonstrated that the passage of centuries and drastic shifts in social mores had transformed an unreflective, direct acting out in Greek mythology into its far subtler, painfully inhibited expression in the seventeenth-century play. That the original Oedipus actually sleeps with his mother after killing his father whereas his later incarnation only wants to do both and signally fails was, for Freud, not a personal idiosyncrasy but a characteristic cultural response. The Oedipus complex is the most intimate

family event, but each age provides it with dominant shapes of its own.*

Modern rebels launched their psychological rebellion against customs and traditions that were their own. No question: they wanted to make it new, even if times of irritation made them wish to burn down museums. But their past, their powerful parents' world, had much to offer them, more than most of them clearly realized. The unusually perceptive American painter Robert Motherwell, whose abstract canvases show no identifiable debt to the past, recognized this when he remarked that every painter carries the history of painting in his head. Just as in the Enlightenment the philosophes turned to ancient pagan wisdom to sustain their fundamental critique of Christian civilization, so neoromantics often pitted one part of their past against another. Manet went to school to the great Velásquez, Gropius to the celebrated early-nineteenth-century German architect Karl Friedrich Schinkel, Schoenberg to the controversial Brahms, Eliot to a very catalogue of past masters. We may question whether Apollinaire's conciliatory statement, "We are not your enemies," was wholly credible, or Baudelaire's much quoted tribute to the

*In his late *Civilization and Its Discontents* (1930), Freud wondered whether one might not be justified to speak of "cultural neuroses" and, though intrigued, urged prudence: "But we should have to be very cautious and not forget that, after all, we are only dealing with analogies and that it is dangerous, not only with men but also concepts, to tear them from the sphere in which they have originated and have been evolved." The same caution applies to the tempting "cultural Oedipus complex."

bourgeoisie of his time wholly sincere. But both hinted at moderns' complicated, at times self-contradictory, positions that they largely hid from themselves.

The catalogue of impediments to an acceptable definition of modernity is not yet complete. Each modern act—a sonata, a comedy, a piece of sculpture—produced the most varied effects on its consumers—not all of them predictable. Arthur Schnitzler's response to the new music and the new painting in the early twentieth century makes this point. The most resourceful playwright, novelist, and short story writer in the Austro-Hungarian Empire, more supple and adventurous than his fellow Viennese moderns, he explored the topic of sexuality and experimented with thoroughly up-to-date devices like stream-of-consciousness narrative. Yet even he reached a point where novelty stepped over the limits of his ability to react with anything but bewilderment and disapproval. In December 1908, he heard the Rosé Quartet perform Schoenberg's atonal second quartet, opus 10, and, with other members of the audience, he balked. "I do not believe in Schoenberg," he confided to his diary. "I immediately understood Bruckner, Mahler—should I fail now?" In the end, he projected his inability to follow this latest, most dramatic step toward modern music on the composer and denounced Schoenberg as a swindler.[21]

Again, in early 1913, Schnitzler visited an exhibition of Picassos in Munich and after years of applauding Picasso's assaults on academic realism found his latest turn downright unintelligible. "The earlier paintings extraordinary," he recorded in his jour-

nal. "Vehement resistance to his current Cubism."[22] Schnitzler thought himself at ease with far-reaching shifts in the arts. As an audacious commentator on the inner world of his characters, as a subtle psychologist who pushed frankness beyond middle-class proscriptions, he could hardly be otherwise. Yet even Schnitzler could not leap over his shadow.

I have borrowed a metaphor from the German painter Max Liebermann, whom the 1870s denounced and admired as a champion of ugliness, as close to French Impressionism as a German artist was ever likely to come. Liebermann welcomed avant-garde artists like Edvard Munch, but was wholly out of sympathy with extreme Expressionists, let alone abstract painters. In the early 1920s, a highly honored artist, he noted (more maliciously than accurately) that buyers of these fashionable monstrosities, whether private collectors or museum directors, gladly sold them.

Getting off the express train from one aesthetic innovation to the next could divide close friends. Mary Cassatt, happily settled in Paris in voluntary, agreeable exile, the only American painter ever to exhibit with the Impressionists, was the most persuasive educator in the cause of modernity. She converted rich visitors from the home country to the new painting and did more to domesticate innovators like Manet and Degas in the United States than the most assiduous art dealer. Yet she too found that the latest developments in painting left her cool, even hostile. In 1912, she urged her close friend Louisine Havemeyer, whom she had earlier persuaded to amass an outstanding collection of modern French artists, including Courbet and Manet, to sell her

Cézannes, whose popularity, she was sure, "cannot last." Surely, "the whole boom is madness and must fall."

Early in the following year, she worried that Louisine had grown too fond of Matisse; he was nothing better than a "farceur." In plain English, Matisse seemed to Cassatt what Schoenberg seemed to Schnitzler: a humbug. She had an explanation for Matisse's brilliant and colorful experiments on canvas. "If you could see his early work! Such a commonplace vision. Such weak execution; he was intelligent enough to see that he could never achieve fame, so he shut himself up for years and evolved his [style] and has achieved notoriety. My dear Louise," she went on, "it is not alone in politics that anarchy reigns."[23] She could not, and did not want to, justify whatever had first attracted her to Matisse. It was the painter's fault that she had in the beginning mistaken his promise! It was a triumphant fact of contemporary culture that the new romantics tried their hand at the most diverse tactics and techniques, and they could not always take their most sympathetic admirers with them. Like the original romantics, they disagreed with their fellows perhaps as strongly as they did with their old-fashioned colleagues. Beginning as early as the 1850s, the modern romantics made not a single revolution but many revolutions.

5

the beethoven decades

Ludwig van Beethoven was born in 1770 and died in 1827. He spent his life in an age of revolutions, notably the American and the French Revolutions, each of them a world changer. They encouraged and compelled him, world citizen as he was, to be an active participant in his time, yet to keep busy as a composer. He wrote, to mention only his secular music, nine symphonies, thirty-two piano sonatas, sixteen string quartets, five piano concertos, and one opera—a highly productive career, slowed down mainly during several years between 1812 and 1820, and steadily open to innovation. As music critics sorted through his materials after his death, they

divided it, a little mechanically, into early, middle, and late Beethoven.

This neat arrangement, though understandable, was less revealing than it might have been; actually Beethoven's "phases" were less sharply silhouetted than this. He ventured into hitherto untried terrain almost from the beginning. His first six string quartets (gathered into op. 18), written by 1801, still belonged to the world of Mozart and Haydn; his next set (the marvelous Razumovsky Quartets, op. 59, nos. 1–3), written five years later, were strikingly original, though in retrospect, Beethoven's last quartets, which date from 1824 to 1827, were even more form-shattering.

The most influential musical expert among the German romantics was certainly E. T. A. Hoffmann, and for Hoffmann, the most romantic composer among them all was Beethoven. Hoffmann's very vocabulary made him a founder and superb disseminator of romantic musicianship. Subjectivity was his master category. "Sound lives everywhere," he wrote in 1813, "but the sounds—the melodies, that is—that speak the higher language of the spirit kingdom inhabit the human heart alone." That is why, for Hoffmann, music was "the most romantic of all the arts, one might be tempted to say, the sole authentically romantic art, because the infinite alone is its model."[1] That, too, is why Hoffmann, that good German Protestant, sharply isolated music as a world that has no truck with the rest of creation.

In 1792, the young Beethoven, then twenty-two, moved to Vienna to study composition with Haydn and other older worthies and never returned. It was a lively time for music making in the

city, when the severely distinctive circles of amateur performers, hitherto sharply kept apart along caste lines, continued to be thus divided, though recently ennobled bourgeois or some of the richest among them were allowed to join their aristocratic brethren as patrons of music. Prince Lichnowsky, who financed a string quartet that performed once a week, was among Beethoven's first patrons; he welcomed the young composer to his estate and for more than a decade treated him as a member of his own family.

The question of democracy in culture was acute and apparently insolvable throughout Beethoven's age. Take one characteristic verdict. In 1881, Alfred Lichtwark, soon to be appointed as director of Hamburg's Kunsthalle, published a terse essay, "Publikum." It divided the public for art into three classes: the masses, the educated, and the elite. The first, he asserted, the largest segment, is almost wholly ignorant of the past, and aware at best of a few etchings after two or three Raphael Madonnas. The second consists of highly educated people (for some reason, not explained further, Lichtwark included historians in this partially benighted category) who possess minimal art-historical information but tend to idealize some single period of the past and, no better than the masses, lack all interest in modern art. The third is a "highly select" population to which only a few may aspire. It knows its art history and is recruited from all social strata. "These are the rarest and the most reliable ones. To be in touch with them is like a revelation, for what they possess as a gift of nature—good taste and their own good judgment—can never be quite attained by

means of education."[2] Unfortunately, they played only a minor role in Germany's artistic life.

This is a remarkable statement, worth pausing over. Its cultural gloom is in tune with the preponderant view that only a small elite can ever mobilize the erudition and the inner freedom needed to seek out and appreciate whatever goes beyond the commonplace and the trifling; most people will never rise above valuing paintings, dramas, novels, as sheer amusement. Lichtwark shared this view, but he partially subverted it by pointing out that cultural leadership may be recruited "from the most varied social strata," from men "who have taken the most diverse educational paths."[3] Like the majority of writers on the coming age of the masses, Lichtwark considered the bulk of the educated bourgeoisie incapable of setting aside its material interests. And in this conviction, he and his fellow aristocrats in the arts were informally allied with the antibourgeois ideologists in the avant-garde. But Lichtwark, with his mystical faith in chosen individuals born with the love of art, went his own way. He was committed to the interesting idea that there is more to taste than money.

Obviously, money, however indispensable, could not wholly account for the emergence and survival of originality in the arts. In the eighteenth century, and even more in the nineteenth, mounting affluence generated avant-garde departures from aesthetic conformity only when the makers of modern art found a home in a relatively liberal political atmosphere. It is only too apparent that twentieth-century totalitarian regimes were from the start,

or soon became, the nemeses of independent art. Dictators and their minions could not tolerate any domain of society beyond their control. They stigmatized subversion, even the most unpolitical subversion of taste, as treason. The Soviet regime would silence or kill its modernists; the Nazis would drive them out or force them into the exile of internal migration; the Italian Fascists, though less rigid, still bent most of them to conformity.

Even the incomparably more permissive nineteenth-century states made censorship a stern reality that innovative spirits dared not ignore. Informal constraints, notably the residual timidity of the bourgeois, were so many acts of collusion with the holders of power. Yet—and this paradox, too, belongs to the story—obstructions inconsistently handled could at times be negotiated or evaded, and then they acted rather perversely as stimuli to assertive modern minorities. When in 1835 legislation prevented that dazzling, audacious draftsman Honoré Daumier from caricaturing Louis Philippe, king of the French, as a pear, he continued to assail the corruption of his country with ingeniously devised oblique substitutes—and made his points as graphically, in both senses of the word, as before. This struggle between power and art took place everywhere, though in two regimes, those of Napoleon III in France (1852–1870) and of Wilhelm II in Germany (1890–1918), it was most conspicuous, displaying with particular transparency the clash between efforts to legislate conformity and chances for creativity under pressure.

Space for artistic independence did much; but successful neo-romanticist subversions also required respectability for artists

before they dared to flout current tastes without being scornfully dismissed as cranks, bohemians, and social climbers, or sent to prison. And Shelley's famous disclaimer about artists as unacknowledged legislators remained, it seemed, true enough. But respectability was within the artists' grasp. Celebrated masters from earlier times, giants in their day, had shown the way: Michelangelo, the "divine" genius who could afford to defy a pontiff; Alexander Pope, who, selling his translations of Homer by subscription, escaped the customary subservience of courting noble applause and financial support by prefacing a work with a servile dedication;* Beethoven, who mastered the world of music simply by being himself, aggressively. His most memorable music—the Third, Fifth, Sixth, and, of course, Ninth Symphonies; such radical departures as the Hammerklavier Piano Sonata; the Razumovsky and the last quartets—fully justify E. T. A. Hoffmann's enthusiastic verdict that Beethoven was the most romantic of all composers.

The reader will have noticed that this judgment apparently contradicts my firm objection to any hint at a coherent romantic movement. Yet I am persuaded that both statements are true in some measure. There were romantic composers in all the cultures that enjoyed even a modest share of musical taste: there was an Edvard Grieg in Norway and a Carl Maria von Weber

*This rough-and-ready derisive sociology anticipates by many decades the tripartite division of the public for high culture which was becoming widely accepted after World War II, with terms like "middlebrow," "midcult," and "juste milieu."

in Germany and an Hector Berlioz in France. All of them were romantics, but they did not teach each other much, if anything. There was at least some overlapping across national frontiers—the lessons that British landscape artists observed from French teachers were impressive and highly visible. But such international thievery was the exception and not the rule. Even such obvious cross-cultural romantic principles as artistic subjectivity that left powerful impressions on most artists in the romantic decades were more likely of domestic origins than truly international borrowings.

Like other romantics, Beethoven too enjoyed a complex reputation. He enormously impressed some of his listeners with his powerful originality; he put off others who found his compositions as somehow beyond the acceptable boundaries of what one may properly call music. Beethoven himself had a disposition to treat his compositions as part of an eternal treasure. A favorite anecdote involves him and a copyist whom Beethoven had asked to finger one of his pieces. His job done, the copyist returned his assignment with the skeptical remark, "Surely what you gave me cannot claim to be music!" To which the composer replied, with astonishing calm: "This is not music for your time."

It was not easy being a friend to Beethoven. There were times —sometimes lasting only a minute and sometimes dominating him for hours, and even weeks—to be miserable and angry (this is the form his paranoid suspicions would take) at his friends, perhaps even his closest, most dependable associates. Money was a particularly sensitive subject for him; the risks of being cheated by publishers were real enough even in the absence of irrational

convictions that would make him their victim. He never married, though he was often in love, and by no means very wisely. Most of the young ladies who studied the piano with him—some of them, it appears, were excellent technicians—were socially so far beyond him that they were reserved for noble young courtiers.

Beyond that, his intimate family life provided a sense of irritation, indeed of real grief to Beethoven. He suffered from a long-lived delusion that he was of noble ancestry. This meant questioning universally accepted evidence from reliable documents that uniformly gave his birth year to have indeed been 1770. His doubt put him at a distance from his parents' family history. And the long-lasting publicly fought drama over his nephew Karl, son of his late brother Carl, was quite as troubling to him; Beethoven sought to win the guardianship over his teenage nephew away from the boy's mother by maligning her and for years tried to secure full custody. This proved to be his most dubious of family fights, since it brought him years of conflict with the boy's mother, open to malicious gossip on Beethoven's personal conduct.

It was Beethoven's habit of self-dramatization that made for a certain uneasiness in his deeper personal engagements. Even after he had built certain affectionate relationships, continuations of friendships depended in large part on Beethoven's moderating his displays of ill temper and his tendency to misread shows of independence as venturing into unwelcome criticism. This was the kind of person he was. Short-tempered, inconsistent in his behavior, but a great man—and if there was no pa-

tience with ordinary folk in his behavior toward them, that was not what good followers and listeners needed to understand and to forgive. What ordinary person, though well trained in the techniques of composition, could create in himself such compositions? This is what romantics taught and learned.

Beethoven, sole maker of the Ninth (1823), is among the first of the moderns. Recent listeners to his Ninth Symphony have discovered musical themes wrestling for expression at least from the 1790s. There is, as the symphony shifts from the first three movements to the fourth, a second of overpowering confusion, with all the musical instruments noisily cooperating by creating a flash of supreme disorder. It is as if violins, woodwinds, trumpets, and all of them together are being quickly and pitilessly discarded from their orchestra. And then we get an instant of total clarity, and we are safe in the fourth movement, ready to listen and to share, a new order.

But his fantasies, most notably his curious, in many respects sad, rapport with his nephew Karl, reflect the composer's odd, in many ways unpleasant, relationship with his family. Among his anxious friends—for he had good friends, not among his aristocratic patrons alone—there was worried talk at times about his sanity, and his struggles with Karl van Beethoven, which took years to resolve and got a certain amount of public attention, only exacerbated his general reputation. Beethoven, that magnificent liberator of sound, did not seem much of a liberator close up.

But late Beethoven was an extraordinary figure. He had composed several masses, but the one that took more time to com-

plete and had more work of correction than any other and made him more famous than its predecessors was the *Missa Solemnis* that he largely completed in late 1822 and really finished the following year. Indeed, in the last half-decade of his life, between 1822 and 1827, he composed more powerful works than he had ever managed to complete before: the *Missa Solemnis,* the Ninth Symphony, and in his final years, a series of string quartets, more complex, more searching, more unprecedented than any of their predecessors. One of them, opus 131, with its seven movements played without breaks, soon became a choice that Beethoven himself once declared his favorite. Beethoven's late music left him a titan.

However profoundly Beethoven's original compositions differed from the contributions of his rivals, they did have something in common: they defied common fashions. Beethoven started to write his Third Symphony sometime in 1802 and had, by the end of the year, largely completed it. Whatever remained to be done was left for the first months of 1803. During that year, he experimented with his new composition in Vienna, most notably at a concert given under the auspices of Prince Lobkowitz, perhaps Beethoven's most consistent patron. Finally, after rehearsals, he introduced his novelty. The first public performance, with music critics in attendance, came on April 7, 1805.

The response was typical for all of Beethoven's major innovations. As the correspondent for the *Freimüthige* put it in a characteristic anonymous review, three distinct parties rapidly developed: there were, on the positive side, "Beethoven's particular friends," who asserted that it is just that symphony which is

his masterpiece.[4] These Beethoven fans were contradicted by another faction who denied "that this work has any artistic value" and claimed the symphony to be "an untamed striving for singularity" that had failed to achieve in any of its parts "beauty or any true sublimity and poetry." To this quarrelsome pair of opponents one had to add "a very small party" that "stands between the others," admitting that "the symphony contains many beauties" but concedes that "the connection is often disrupted entirely,"[5] and was distinctly inferior to his two earlier symphonies.

All these thoughts bring us back to the first romantics who have been the center of our attention, the climate of Novalis and the brothers Schlegel. Beethoven, even if he said so rarely, was fully aware that his world of music, specifically his compositions, went far beyond his age, and that of his Hapsburg cast of admirers. He was writing for all ages.

epilogue

The productivity of modern artists was not unlimited. Yet its contribution to cultural discussion was widespread and highly appreciated, and made the work of critics at once fascinating and strenuous. Then exhaustion set in. In 1933, Sir William Walton— still plain Mr. Walton then—wrote in deep discouragement, "I think it is almost impossible for anyone to produce anything in any of the arts nowadays." He was disparaging his sluggish tempo of composing, but he caught a widespread mood of gloom among modern artists; the favorable political, economic, and social conditions central to originality in the arts had been fading, indeed disappearing, for some time.

Looking back, the historian notes that modern art seemed more triumphant during the two or three decades before the World War and kept radical impulses alive until the peace treaties followed. The harvest of that time is so ample and diverse that it is risky to single out one quality shared by all modern classics. But one continually claims and reclaims consideration: the

impassioned summarizing of the moderns' core convictions. Not that conventional artists had necessarily shirked the search for truth. But they had (at least as the moderns saw it) failed to use all available instruments to find it. It was in service to their fundamental inquiry that the scientific study of mind gained new prominence. It is felicitous but unsurprising that these should be the decades in which Sigmund Freud developed the deepest of depth psychologies: psychoanalysis.

The case for modern art was, of course, not psychoanalytic doctrine. The time was a time of intellectual commotion. New religions and secular ideologies, all of them claiming to have privileged access to hidden truths, all of them likely to assert that their keys to these truths were superior to those of their rivals. Their disclosure of self was a key symptom of the charms of inwardness: attempts to investigate the underlying meaning and pitfalls of language were not confined to psychoanalysts. As early as the 1840s, Thomas Carlyle had already called his time an autobiographical age, and the interest in self-exhibition only grew across the decades. Nor were trained artists alone in reporting their history for a wider audience. Untold thousands of respectable youngsters were taught to keep diaries, logbooks of feelings, tastes, and events, and for many this childhood activity became a lifelong habit. Then, a number of these confessions, relatively frank and unsparing, made their way into formal autobiographies.

In publishing their life histories, not exempting their feelings, or compiling a record of their appearance in paintings or graphics, then, moderns developed theories about the psychological

roots and effects of artistic creativity, but when it came to discriminating among schools of architecture or painting, strictly personal tastes prevailed. Nearly all the analysts of the first generation were, much like Freud himself, educated bourgeois with conventional predilections, far more attached to classics in poetry or painting than subversives intent on overthrowing academic art or the well-made play.

Yet in its commitment to an uncompromising scientific style of thinking, psychoanalysis belonged securely to the modern camp. It was only fitting that Freud should have drawn metaphors from the social sciences or archeology to illustrate psychoanalytic technique, speaking of excavating and restoring repressed material. Working with his analysands patiently and attentively, he and his followers were producing assisted autobiographies, a strictly modern pursuit. The most influential among them, notably the Impressionists and the Expressionists, memorably underscored inward impulses at the hub of their art. These painters put history, genre, ancient myth, certainly the assiduous imitation of external influences aside, as they principally listened to their profound personal responses in their search for objective aesthetic correlatives. Indirectly but potently, their canvases were confessions. To be sure, some of this name-giving (or name-calling) was tendentious: "Fauves," or wild beasts, a scarcely flattering label for André Derain, Henri Matisse, and Maurice de Vlaminck, whose high-spirited, brilliantly colorful canvases first shocked the public in 1905, was excessive: their landscapes were exuberant commentaries on a recognizable world.

This profusion of labels strongly suggests an unquenchable ap-

petite for an identity by painters cut loose from traditional standards, an often anxious eagerness to form or join a school with a distinct program that would recognize their special gifts and give them their share in the great rebellion against the commonplace. From that perspective, the Secessionist mini-rebellions that erupted among German and Austrian painters during the 1890s were symptomatic of a mounting discontent with accepted conventions, as one school of antiacademic artists soon succeeded, and often felt itself superior to, its predecessors. In the years before the First World War, the shifts of generations among painters had never been so rapid and abrupt, and would not be so again until the 1960s. Avant-gardes marched under the common flag of the modern, but they were differentiated by more insignia than there were fundamental artistic divergences. Impressionism, Post-Impressionism, Neo-Impressionism, Symbolism, Expressionism, Orphism, Cubism, Futurism, Suprematism, Neo-Plasticism, Surrealism, accompanied by the Nabis and the Fauves, crowd the pages of history after the turn of the twentieth century.

They matter to the historians of modern art. And they thought they were both important and necessary. As Giorgio de Chirico, the undisputed spokesman for the Italian Metaphysical School, put it with his usual grandiosity in 1919: "A European era like ours, which carries with it the enormous weight of infinite civilizations and the maturity of many spiritual and fateful periods, produces an art that in certain aspects resembles that of the restlessness of myth. Such an art arises through the efforts of the few men endowed with particular clearsightedness and sensibility." Although comparable tumults roiled the waters in the other arts,

composers or playwrights or choreographers were not as quick as the painters to provide themselves with new identities. These were times, then, for rudely questioning the long-honored rules in all the arts, for mocking highly paid established virtuosos, for sending into retirement well-loved stylistic formulas, outworn religious prescriptions, self-protective prudery, and anachronistic mannerisms that together had dominated the cultural landscape for centuries.

Beyond Impressionism the modern art spreading across Western culture was, in the words of Germany's Emperor Wilhelm II, the art of the gutter. Modern artists took this imperial insult as an incentive. Whatever the kaiser might say, following their star, they believed themselves on the right path to artistic truth. The losses seemingly attached to their bold subjectivity were really hidden gains: the mimetic precision that had for so long served as the touchstone for taste in painting and sculpture, fiction and drama, was to them inexcusably old-fashioned. But the triumphs of the new were not yet assured. As new romantic artists everywhere complained, consumers who blindly trusted in tradition and complacently preferred easily digestible kitsch to the more arduous labor of securing lasting aesthetic pleasure, were influential and tenacious.

In that bellicose atmosphere, good moderns considered Ezra Pound's famous injunction "make it new" to be Scripture. Of all the ways that modern painters could express their innermost feelings, making self-portraits put them into the closest possible touch with their viewers. These looks into the mirror were monuments to subjectivity, not pathological enough to qualify as acts

of narcissism, but assertive enough to serve as documents of self-regard. They added up to a record of intense preoccupation with self that procured the artist a tentative immortality and at the same time attested to a certain respectability. The despised and rejected did not paint their self-portraits. To be sure, the moderns had not invented the genre. Some of the most celebrated, most expressive self-portraits date back at least four centuries, to Albrecht Dürer, who had shown himself in a variety of imaginative poses, including as Man of Sorrows. And Rembrandt's legendary series of self-portraits suggests that neurosis was a precondition for artistic gifts; this causal linkage has never been established, though in the years of modern art the supposed tie between them became a favorite topic for psychologists and a popular cliché among the educated.

Life history after life history during the moderns' classic period seemed to lend support to the theory that genius and madness were (to recall Shakespeare) near allied. Indeed a then highly influential criminologist, Cesare Lombroso, whose doctrinaire and ill-documented assertions about the predictable criminal mentality and the degeneracy of genius captured the attention of newspaper readers and the enthusiastic assent of the medical profession, further cemented this legend. Vincent van Gogh and Paul Gauguin, among the greatest, certainly among the most prominent of modern painters, sufficiently exhibited the expected symptoms: the first shot himself to death after a succession of terrifying psychotic breakdowns, the second deserted his wife and five children and his career as a stockbroker to spend the rest of his days in distant, impoverished exile, painting, painting.

The oeuvre of these two masters of expressive inwardness attests to the substantial share of self-portraits in the careers of modern painters determined to carry further the aesthetic revolution launched by the classic Impressionists. With their fairly rapid triumph among collectors, Monet and his associates had forced the door to unconventional departures, and the generations that followed them, half-grateful, half-insistent on their own originality, poured through it. I recall Gauguin's complaint that the Impressionists were painting "without freedom, always shackled by the need of probability." It was a frontier that others in his party were determined to cross. They would paint horses blue, Christs yellow, faces green, and devote close attention to such "inartistic" motifs such as shoes and chairs. As the greatest among Symbolist artists (a comprehensive label borrowed from modern French poetry mainly associated with the verbal experiments of Mallarmé), they were intent on capturing their deepest personal responses to the world rather than rendering that world as accurately as was in their power.

In short, though both Gauguin and van Gogh thought the Impressionists' subversion of Salon art eminently worthy of respect, their own paintings offended conformist tastes so decisively that the exhibitions winning them a larger market were largely posthumous. Van Gogh had shown a handful of paintings before his suicide in 1890, but was not launched on his rise into universal favor and astronomic prices until 1901, with an exhibition at the Bernheim-Jeune gallery in Paris. And the Salon d'Automne put Gauguin on the map in 1906, three years after he had died in the Marquesas virtually unknown outside a tight

coterie of admirers. Both came to painting late, but once they did, they pursued their vocation with obsessive, religious fervor. When they painted self-portraits, they did so for themselves, and, as we shall soon see, for one another.

If van Gogh and Gauguin were in their self-portraits showing themselves without bourgeois reluctance, Paul Cézanne gave away quite as much, though more subtly, by aiming to give away nothing. Few students of Cézanne have missed the studied impersonality in the scores of paintings and the drawings he did of himself. He fitted them securely into the highly individual, tensely alive architectural modern classicism that became his mark in his mature work. In the 1860s, a young painter learning his craft—he was born in Provence in 1839—he specialized in imaginary scenes of melodramatic brutality: rapes, orgies, murders. Nor was his earliest self-portrait, dating from around 1861 and painted after a photograph, much more inhibited in its emotional exhibitionism. He transformed his rather round, commonplace face into a gaunt, threatening presence, pulled together his black eyebrows into a brooding frown absent from the snapshot, and curved his mustache to make himself scowl. More faithful to his state of mind in the painting, it seems, than in the photograph, he has portrayed himself as a troubled, angry young man.

But with the early 1870s, after he had undergone an informal training with Pissarro, though always resolutely his own man, he shared the Impressionists' palette and exhibited with them more than once. He gave up intervening episodes of extreme sexual

and aggressive violence, and mastered his urges with apparently cool, distant, carefully thought-out landscapes, interiors, and portraits, and those astonishing late constructions, the canvases of bathers.

As he developed into the sovereign source of twentieth-century art—Picasso and Braque in their Cubist phase were only the most eminent of his many disciples—Cézanne would organize arrangements of ripe, round, luscious apples on a disheveled table cloth, or two card players face to face, or return again and again to paint his beloved Mont Sainte-Victoire. Strange, difficult paintings all of them, violating perspective and straining natural shapes, mute witnesses to a sensual nature fiercely held in check. It is no wonder that his breakthrough to fame was delayed to 1907, through a sensational retrospective at the Salon d'Automne, a year after his death.

Cézanne's most important self-portraits, largely concentrated in two decades from the mid-1870s to the mid-1890s, are even more consciously, almost desperately, reserved. He subordinated everything, shapes, colors, broad shoulders to his overall design. He contrasted his boldly curved, shiny pate with a strong diamond-dominated wallpaper in the background, held his palette like an extension of his right arm. He looks worried, unkempt, always distant, laying on colors with short, visible parallel strokes to proclaim the presence of a painting far more than of a person. And he painted his eyes, which, the ancient truism has it, are the windows of the soul, opaque, impenetrable. For all that, the blank stares that Cézanne bestowed on the viewer were

accomplices to an irresistible indiscretion. His self-portraits betray their very secret he aimed to keep: he was a man who all his life tried to impose order on an unruly, perhaps chaotic self.

His self-portrait sketches—Cézanne did more than twenty of them—were less thoroughly designed and they document his appearance more spontaneously. In fact, two or three of these quick glimpses into the mirror show a worry line over the bridge of his nose or his lips tightly pressed together, making him look recessive and careworn. All in all, Cézanne's artistic reactions to his inner turmoil shore up Freud's assertion that try as they will, humans cannot keep their secrets. Conflicts will out, defying efforts at concealment; however handled, they leave traces along the way. This must be true particularly for the world of the moderns, freed of so many constraints and so much self-control. In his last years, Cézanne, feeling defeated and solitary, stopped doing self-portraits altogether, banishing distress as much as exuberance, perhaps even more.

With all their unrelieved emphasis on the artists' self, romantics were devoted to self-portraiture, but they did not regard this preoccupation as anything new. They did their work as the proud heirs of Dürer—and of Rembrandt.[1] Whatever Rembrandt's deeper motives may have been for his self-preoccupation (even more than Dürer, he left precious little autobiographical material for the historian), late-nineteenth-century cultural and political German nationalists exploited him as a pawn in the campaign to prove their country's superiority to other, lesser cultures in inwardness—

Innerlichkeit. For political purposes, the Dutchman Rembrandt conveniently became a German. So did Wassily Kandinsky.*

That backward glance—like other neoromantics the Germans too did not disdain the past for the sake of abstract art. "Suddenly," Kandinsky, returning home after a day's sketching around 1910, recalled, "I saw an indescribably beautiful picture soaked in an inner glow." He rushed over to the perplexing canvas on which he saw only forms and colors. "It was a picture I had painted, leaning against the wall, standing on its side." In bright daylight he would recognize the motif, hence the effect was less impressive. The explanation quickly seized him: "I knew for certain that the object harmed my picture." The faithful rendering of reality now appeared to be the supreme obstacle to art. His conclusion was utterly sweeping: "the aims (and thus the means) of nature and art are essentially, organically, and by universal law different from each other."[2] He had made a pictorial statement that owed nothing to the external world.

Whether Kandinsky's reminiscence is a trustworthy report on a dazzling insight or (which is more likely) the dramatized con-

*For the record, I should note briefly that Velázquez's famous *Las Meninas* showed him at work in the royal quarters. Rubens, Poussin, Reynolds all painted themselves. In the mid-eighteenth century, Anton Raphael Mengs, Germany's most important painter, did at least fifteen self-portraits from youth to middle age, and the German late-eighteenth- and early-nineteenth-century painter Anton Graff, one of the most productive painters of any time, set some sort of record by painting himself eighty times or more.

densation of a more protracted retreat from the ideal of mimesis, thus to pit art against nature was indeed an epochal event in the history of modern art. Most artists who in these heady years cut the links to external realities reached that decisive point only after years of working toward their characteristic style. Their pilgrimage—to them it seemed nothing less than this—was an illuminating illustration of, and tribute to, the individualism that lies at the core of modern art, with its passion for the shocking, its sovereign disregard of accepted conventions, art for artists' sake in the extreme, a rather ramshackle mystical system concocted of Russian folk tales, the theosophical dogmas of Madame Blavatsky, an extraordinary susceptibility to musical as much as visual stimuli, and a sense of mission to rescue spirituality from the corrosive effects of contemporary "materialism." The modern world, Kandinsky believed, much like German romantics a century earlier, had lost its soul and desperately needed to be re-enchanted, and art alone could do that.

All together this "philosophy" added up to a heavy dose of recycled romanticism, that vague catchall term that Kandinsky liked to claim as his own. "If today there should be a new objectivity —*neue Sachlichkeit*—let there also be a new romanticism," he wrote in 1925, and added, "the meaning and content of art is romanticism," which meant to him a creative, highly unorthodox creed that, without rigorously excluding the intellect, placed the artist's and the viewer's feelings at the heart of aesthetic experience.[3] That there were many who disagreed with him, and that he was aware of it, emerges from his wishful, almost wistful, formulation—"let there also be a new romanticism." Its pros-

pects were on the whole dim, but Kandinsky's plea once again illustrates the sheer variety of modernist motivation. This new romanticism was making its way after half a century particularly hospitable to new pieties, or to old pieties tailored to modern tastes—theosophy, anthroposophy, Christian Science, and a bewildering menu of beliefs ranging from primitive credulity about messages from the beyond to the civilized, semiscientific investigations of the English Society of Psychical Research. The hunger for a spiritual message holding out hope that death was not the end seemed impossible to assuage in what those aching to believe in something detested as a frigid scientific universe. Hence one version of spiritualism or another became the superstition of intellectuals and the educated. If all officially recognized denominations had proved bankrupt, if the holy story the Bible tells is incredible, still the authentic kernel of the sacred, these modern would-be believers convinced themselves, must be preserved and allowed to ripen free from traditional sectarianism. It was in this turbulent atmosphere that a substantial wing of the new romantics, among whom avant-garde painters were prominent, cast their impatience with conventional styles and thinking in religious form.

Paradoxically but not surprisingly, many susceptible to the exotic currents swirling around them tried to pursue their campaign for the new with a detour through the past. They substituted the comfort of the old for the shock of the new. Wagner's "Music of the Future" exploited medieval Teutonic legends. Pre-Raphaelites aiming to renew painting in England called for a return to late-medieval models. German and English modernist

painters like Max Ernst and Graham Sutherland took inspiration from the *Crucifixion,* an emotionally overpowering altarpiece by the early-sixteenth-century German artist Matthias Grünewald. Kandinsky belonged to this party. In his best known essay, *On the Spiritual in Art* (1912), extensively read and widely translated, he noted, rummaging through notions recent and remote, that the "inner-essential" similarity between simpler times and the present world would reveal "the seed of the future."

Kandinsky's mysticism was the triumph of personal urges over professional training. Born in Moscow in 1866, he was schooled, and well schooled, in law and economics, but gave up a career in the "real world" and moved to Munich in 1896 to study painting. He made himself into a skilled draftsman and painter of strongly colored, sometimes storytelling landscapes. And he showed himself, for all the isolated position he was steering toward, an inveterate founder and joiner of avant-gardes. Yet somehow none of his incessant activity was enough. If he looked for an artistic language to express his most secret emotions, it was a new, cosmopolitan vocabulary he wanted. And by around 1910, about the time he saw his canvas on its side and in dim light, he felt that he had reached his goal. Nonrepresentational art with no reference to subject matter was born. This shocking new painting, soon practiced by a cohort, confronted art critics with unprecedented risks: one proposed reading of these canvases seemed as good as another. Kandinsky said somewhere that the more interpretations one of his paintings invited, the better. If he seriously believed that, and apparently he did, he must have judged each of them a rousing success.

During his early years as an artistic iconoclast, Kandinsky juxtaposed splashes of vividly contrasting irregular patches of color and spots in other colors invading the larger fields, often adding a dramatic streak of black traveling across the canvas. Some of the shades he chose were suggested by his reading in theosophy, but all emerged from an inner, unidentifiable pressure. In his years in Moscow from 1916 to 1921—he welcomed the Russian Revolution and actively engaged in teaching and administration in the new regime until he found that his modernist abstractions were not welcome—he began to organize his figures more rigidly than before. He drew clearer, sharper outlines, relying in part on circles, straight lines, and half-moons, but continued to paint mysterious shapes overlapping and brushing up against one another.*

The small forms he used at times made for a humorous symphony, some of them hazily resembling, but never truly imitating, structures appearing in nature. He introduced teasing shapes that could be interpreted as the portals of a cathedral or a horseback rider, but this only made his inventions appear more esoteric. Not even his mood—or the mood he intended to express—ever seemed unambiguous. In short, from the time he adopted abstraction, his paintings were almost literally indescribable. He worked vigorously, often in trouble, to the end of the First World War. The clan of abstract painters had grown to a

*This was not a purely internal development; he was responding to the abstractions of his fellow Russian the Suprematist Kazimir Malevich and the Constructivism developed by the great illustrator El Lissitzky.

small but fervent bevy of aesthetic extremists. Not all of them regarded their output as a form of worship; the witty French artist Robert Delaunay, for one, with his vividly colored swirls worked not to articulate a religious message but to exhibit a color theory. Yet at least one leader in the abstractionist camp, the Russian Kazimir Malevich, deserves particular attention because the paintings he did from the late 1910s to the early 1920s in his Suprematist phase—it was a name he had coined—were the most sweeping exemplars of nonobjective art. Like Kandinsky imbued with Russian folk religion and unlike him occasionally identifying the artist—himself—with God, Malevich reduced painting to elements more distant from nature than even Mondrian's. In 1913, he exhibited a black square within a white rectangle and, four years later, topped this seditious canvas with a slanting white square inscribed in a white rectangle of a barely different hue. To appreciate even the appearance of *White on White* required not just artistic open-mindedness but keen eyesight. Beyond this monochrome there was only an empty canvas.

For Malevich, his simple-looking paintings were the incarnation of a spiritual ideology. To put it bluntly, he wanted to put something in the place of nothing, artistic sensibility instead of capitalistic greed. "By Suprematism," he wrote, "I mean the supremacy of pure feeling or sensation in the pictorial arts." As he recalled his awakening, it had been "in the year 1913 in my desperate struggle to free art from the ballast of the objective world" that he had "fled to the form of the Square." That square, he insisted, was not empty, but "rather the experience of objectlessness." Such thinking took art—and of course the artist—very seriously.

When Malevich maintained that the time was ripe for a new religion, he meant a new aesthetic.[4] Among the leaders of this aesthetic revolt, the one painter whom even the most amateurish museum visitor public can instantly identify was the Dutchman Piet Mondrian. He and his only possible rival, Wassily Kandinsky, were as different as two artists can possibly be. Kandinsky was gregarious, Mondrian austere, and though never without friends, a solitary explorer. Kandinsky could never be without female companionship; Mondrian was, even though there are a few reports (all of uncertain reliability) about some unhappy romantic attachments, very much the professional bachelor. Those who had observed him noted that the one dance he truly liked was the Charleston, in which one does not touch one's partner. Kandinsky was a born educator, spending eleven years as a professor at the Bauhaus until it was closed in 1933, teaching drawing and wall painting with enthusiasm and consistently enjoying gratifying popularity with his students. Mondrian kept publishing the same rhetorical effusions about his private doctrine, Neo-Plasticism. Kandinsky invented ever new forms for his pious quest. Mondrian, after settling on his celebrated grids, varied them only in accord with a minutely calibrated program. Yet the parallel evolution of their careers is striking. Both spent most of their lives abroad, drew their mystical notions largely from theosophy, and—this is most important—took their painting to be more than mere painting—a form of prayer. Both, then, were seekers who found in their art the solution to their religious perplexities, as they resolutely turned their back on nature.

Mondrian did so literally. In late 1940, he migrated from

Great Britain to the United States, his now celebrated abstract rectangles known mainly to a select circle of American collectors. Among the artists who befriended him in his last few years—he died in 1944—was the abstract painter Robert Motherwell, who could afford to take, and enjoyed taking, his Dutch fellow artist out to dinner. The two sometimes went to the Tavern on the Green, an old New York standby that fronts on Central Park. When the weather was fine, Motherwell reports, the two would take a table outdoors, and Mondrian would insist that he sit with his back to the park's lush greenery.[5]

This was not an abrupt reversal by an old man threatened with senility. As a young painter, he had done some striking Dutch landscapes and flower pieces, but he was to shift away dramatically from such conventional subjects. As early as 1915—he was then forty-three—taking a walk with a friend in the Dutch artists' village of Laren, and talking about the effect of moonlight on landscapes, Mondrian abruptly exclaimed, "Yes, all in all, nature is a damned wretched affair. I can hardly stand it." This was not just a matter of taste; it attests to his fundamental beliefs.

In 1938, in London, Max Beckmann, who has emerged in recent decades as Germany's supreme modern painter, philosophized about self-portraiture in a much-noted lecture. Speaking a year after the Nazis had included his work among exemplars of "degenerate art," he prudently stayed away from political comment. All the more reason to speak with some freedom about his motives for taking his face and figure as a subject, as he so often did. "All objective spirits," he said, "press toward self-portrayal—*Selbstdarstellung*. I search for this self—*Ich*—in my life and in

my art." This exploration was, to his mind, every artist's most urgent and most demanding assignment. "Since we still do not know what this self really is, this self to which you and I give expression, each in our own way, we must push toward its discovery more and more deeply. For this self is the great, veiled mystery of existence." He characterized himself as "immersed in the problem of the individual," and tried to "represent it in every way. What are you? What am I?" he asked. "These are questions that incessantly pursue and torment me and perhaps also play a certain role in my art."[6]

This "perhaps" was unnecessarily guarded. Without committing himself to philosophical doctrines like Schopenhauer's or accepting what he called the "nonsense" of theosophy, he perused both. All his days he fished in deep waters, agonizing over the meaning of life—and of himself. In this enterprise, unsystematic but heartfelt, Beckmann's self-portraits were an essential element, never a casual interlude to relax from some more strenuous project. They are among his most potent—and most appealing—creations, as they emphasize his squarish head, jutting chin, and balding forehead, all modeled with a sure hand and a stunning control of color. He punctuated his work with self-portraits from the beginning of the twentieth century to the year of his death in 1950, in drypoints, woodcuts, lithographs, drawings, and paintings. More than once he smuggled his likeness into the large, ambitious triptychs he began to paint after the First World War.

One of his earliest self-portraits, dating from 1901, when he was seventeen, is a striking exercise in technique, an etching that

shows him open-mouthed, screaming. But at the heart of his intentions was the substance of his self rather than the flashy aesthetic pirouettes he might be able to perform. He shows himself soberly dressed, a cigarette dangling from his right hand, or, in a tuxedo, with the cigarette in his left—these pictures and their companions attest that however insecure his health in later years, he never stopped smoking. Again, he paints himself as a painter, improbably wearing a hat, holding a brush and palette. He is a clown or a pedestrian on a crowded city street, a musician with an unnaturally bulbous saxophone, a husband with his wife—twice, with his first and his second. He is in self-imposed wartime exile in Amsterdam sitting with three friends, or alone, crowding out all background with his massive head. Again, in his brilliant half-length self-portraits, painted in 1938 while he was already living in Amsterdam—it is one of his most impressive canvases—he shows himself in a red-and-black-striped jacket holding a horn, one of his favorite props. His moods are as varied as his attire: truculent, frightened, thoughtful, defiant.

Unlike their nineteenth-century forebears, then, their twentieth-century heirs simply neglected their origins. They were new men—and in some impressive ways new women—who were so preoccupied with being new that their history only rarely troubled, or inspired, them. But indirectly, they lived off the past. We no longer read much William Wordsworth—we have T. S. Eliot. We no longer amuse our free hours with Sir Walter Scott—we have Virginia Woolf. It is not that we despise our literary and musical ancestors, but if we did not have the univer-

sities, the classics—as we are sure to call these—would be largely reduced to assignments, or revived by impassioned students who find, say, Jane Austen as thrilling as though she, too, were new, and speaking to us in surprising modernity. What is forgotten, unjustly, is the rich romantic past that was the first to question age-old traditions, and to teach novelists and poets, composers, painters, and dramatists, to say nothing of architects, where its creators' passions originated and how much they still live in that world.

notes

.

PROLOGUE

1. Peter Gay, *The Bourgeois Experience: Victoria to Freud,* 5 vols. (New York: vols. 1–2, Oxford University Press; vols. 3–5, W. W. Norton, 1984–1998).

2. Arthur O. Lovejoy, "On the Discrimination of Romanticisms" (1924), in *Essays in the History of Ideas* (Baltimore, 1948), 229.

3. Ibid., 253.

CHAPTER ONE: "THE RE-ENCHANTMENT OF THE WORLD"

1. Novalis, *Schriften,* ed. Paul Kluckhohn and Richard Samuel, 4 vols. (Leipzig, 1960–1975), 2: unsequenced fragment.

2. Novalis, *Blüthenstaubfragment,* in *Werke, Tagebücher und Briefe Friedrich von Hardenbergs,* ed. Hans-Joachim Mähl and Richard Samuel, 2 vols. (Munich, 1978), 1, no. 14: 462, 463.

3. Friedrich Hölderlin, *Hyperion* (1797–1799), "Über Religion," in *Sämtliche Werke und Briefe,* ed. Günter Mieth, 2 vols. (Munich, 1970), 1: 657.

4. Novalis, "Longing for Death," in *Hymns to the Night and Other Selected Writings,* trans. Charles E. Passage (New York, 1960), no. 6.

5. Friedrich Schleiermacher, *Reden über die Religion* (1799), in *Leben Schleiermachers,* 2 vols., ed. Wilhelm Dilthey (Berlin, 1922), 1: 35.

6. Friedrich Schleiermacher, *On Religion: Speeches to Its Cultural Despisers,* trans. John Oman (London, 1893), 278, 277.

7. Friedrich Schleiermacher, *Reden über die Religion,* in *Kritische Gesamtausgabe,* 15 vols., ed. Hans-Joachim Birkner, Gerhard Ebeling, et al. (Berlin, 1984), 1st division, 2: 221.

8. Friedrich Schlegel, letter to Dorothea Veit in *Friedrich Schlegel, Theorie der Weiblichkeit,* ed. Winfried Menninghaus (Frankfurt, 1983), 85–119.

9. Friedrich Schlegel, *Lucinde* (1799; Goldmanns Gelbe Taschenbücher, n.d.), 17; all translations are my own unless otherwise specified.

10. See Friedrich Schlegel, in *Athenaeum* (1798), passim.

11. Friedrich Schlegel, "Der universelle Republikanismus" (1796), in *Schriften und Fragmente; ein Gesamtbild seines Geistes,* ed. Ernst Behler (Stuttgart, 1956), 295–301.

12. Benjamin Constant, *Adolphe* (1816), cited in Jann Matlock, "Novels of Testimony and the 'Invention' of the Modern French Novel," in *The Cambridge Companion to the French Novel: From 1800 to the Present,* ed. Timothy Unwin (Cambridge, 1997), 28.

13. Victor Hugo, *Préface de Cromwell and Hernani* (1827), in *The Lake French Classics,* ed. John H. Effinger (Chicago, 1900), 53–54.

14. Chateaubriand, *Génie du Christianisme,* part 2, book 3, chapter 9, quoted in Alexandre Rodolphe Vinet, *Chateaubriand* (Lausanne, 1990), 138.

15. Alfred de Vigny, quoted in Peyre, *What Is Romanticism?* chapter 5, passim.

16. Stendhal, *Oeuvres intimes,* ed. Henri Martineau (Paris, 1955), 60.

17. Stendhal, *De l'amour* (1822), ed. Henri Martineau (Paris, 1938), 21.

18. Ibid., 80.

19. Ibid., 42, 46, 63.

20. Ibid., 122.

21. Honoré de Balzac, Préface, *Physiologie du mariage,* ed. Maurice Regard (1829; Paris, 1968), Meditation IV, 58.

22. Lord Byron, letter dated January 19, 1819, to John Cam Hobhouse, in *Byron's Letters and Journals,* 11 vols., ed. Leslie A. Marchand (Cambridge, MA, 1973), 6: 92.

23. August Wilhelm Schlegel, quoted in Eckart Klessmann, *Die deutsche Romantik* (Cologne, 1979), 79.

24. Philipp Otto Runge, undated letter (circa 1801 or 1802), in *Hinterlassene Schriften,* 2 vols. ed. by his older brother (Hamburg, 1840–1841), 1: 179.

25. Novalis, *Die Christenheit oder Europa,* in *Fragmente und Studien,* ed. Carl Paschek (Stuttgart, 1996), 86.

26. Friedrich Hölderlin, "Über Religion," *Sämtliche Werke und Briefe,* ed. Günter Mieth, 2: 864.

CHAPTER TWO: ROMANTIC PSYCHOLOGY

1. Henri Matisse to Pierre Bonnard, in Elizabeth Cowling et al., *Matisse/Picasso* (New York, MOMA, 2003), 292.

2. Friedrich Nietzsche, *Beyond Good and Evil: Prelude to a Philosophy of the Future,* ed. Rolf-Peter Horstmann and Judith Norman, trans. Judith Norman (1886; Cambridge, 2002), 24.

3. Comments quoted and summarized in George Bernard Shaw, *The Quintessence of Ibsenism* (1891; New York, 1912), 3–4.

4. T. S. Eliot, Introduction, *Literary Essays of Ezra Pound* (Westport, CT, 1954), xiii.

5. Cited in Werner Hoffmann, *Turning Points in Twentieth-Century Art, 1890–1917,* trans. Charles Kessler (New York, 1969), passim.

6. Letter from Camille Pissarro to Lucien Pissarro, quoted in Theodore Reff, "Copyists in the Louvre, 1850–1870," *Art Bulletin* 46 (December, 1964), 553*n*.

7. Letter from Paul Gauguin to Émile Schuffenecker, dated October 8, 1888, in Gauguin, *The Writings of a Savage,* ed. Daniel Guérin, trans. Eleanor Levieux (New York, 1996), 24

8. Filippo Tommaso Marinetti, *Manifeste initiale du futurisme, Le Figaro,* February 20, 1909, reproduced in *Le premier manifeste du futurisme,* ed. Jean-Pierre A. de Villers (Ottawa, 1986), 51.

9. Man Ray, quoted in Herbert R. Lottman, *Man Ray's Montparnasse* (New York, 2001), 18.

10. Robert Louis Stevenson, "Walking Tours," in *Essays by Robert Louis Stevenson,* ed. William Lyon Phelps (New York, 1918), 32.

11. Letter from Gustave Flaubert to Louis Bouilhet, dated December 26, 1852, in *Correspondance,* 6 vols., ed. Jean Bruneau (1973–2007), 2: 217.

12. See Emily Braun, *Mario Sironi and Italian Modernism: Art and Politics Under Fascism* (New York, 2000), 50.

13. Claes Oldenburg, quoted in Dore Ashton, "Monuments for Nowhere and Anywhere," *L'Art vivant,* July 1970, rpt. in *Idea Art: A Critical Anthology,* ed. Gregory Battcock (New York, 1973), 12.

14. Harold Rosenberg, *Discovering the Present* (Chicago, 1973), 15–16.

15. Piet Mondrian, "Toward the True Vision of Reality" (1941) in *Plastic Art and Pure Plastic Art and Other Essays,* ed. Robert Motherwell (New York, 1951), 10.

16. Salvador Dalí, *The Secret Life of Salvador Dali* (1942), quoted in Francine Prose, "Gala Dalí," *The Lives of the Muses: Nine Women and the Artists They Inspired* (New York, 2002), 198.

17. Charles Baudelaire, "Salon de 1846," in *Oeuvres complètes,* ed. Y.-G. Le Dantec, rev. ed. by Claude Pichois (Paris, 1961), 874–875.

18. Michael R. Taylor, "Between Modernism and Mythology: Gior-

gio de Chirico and the Ariadne Series," in *Giorgio de Chirico and the Myth of Ariadne* (London, 2002), 17.

19. Guillaume Apollinaire, "La Jolie Rousse," in *Calligrammes, poèmes de la paix et de la guerre* (1913–1916), preface by Michel Butor (Paris, 1966), 184.

CHAPTER THREE: MIDDLEMEN AS PEDAGOGUES

1. "The Ethics of Art," *Musical Times and Singing Class Circular* 30 (May 1, 1889), 265.

2. Henry James, "Criticism" (1891), in *Selected Literary Criticism,* ed. Morris Shapira (New York, 1963), 167–168.

3. Gustav Pauli, Introduction, *Alfred Lichtwark, Briefe an die Kommission für die Verwaltung der Kunsthalle,* 2 vols. (Hamburg, 1924), 1: 15.

4. Alfred Lichtwark, "Museen als Bildungsstätte" (1903), in *Erziehung des Auges* (Frankfurt, 1991), 47.

5. Alfred Lichtwark, *Briefe an die Kommission,* June 24, 1897 (from Brussels), 1: 271.

6. Ibid., June 26, 1892 (from Paris), 1: 97.

7. Ibid., June 16, 1898 (from Paris), 1: 322–323.

8. Ibid., 1: 323.

9. Ibid.

10. Ibid., 1897.

11. Ibid., April 24, 1897 (from Paris), 1: 250–252.

CHAPTER FOUR: ART FOR ARTISTS' SAKE

1. Théophile Gautier, *Mademoiselle de Maupin,* ed. Geneviève van den Bogaert (1835–1836; Paris, 1966), 45.

2. "Profession de foi," *L'Art libre: Revue artistique et littéraire* (Brussels) 1 (December 15, 1871), 1–3.

3. Edmond Goncourt and Jules Goncourt, *Manette Salomon,* new ed. (1867; Paris, 1897), 323.

4. Richard Wagner, "A Pilgrimage to Beethoven" (1840), in *A Pilgrimage to Beethoven and Other Essays,* trans. William Ashton Ellis (Lincoln, NE, 1994), 21–45.

5. William Blake, quoted in Irene Langridge, *William Blake: A Study of His Life and Art Work* (London, 1904), 67.

6. Richard Dehmel, cited in Peter Gay, *Modernism: The Lure of Heresy, from Baudelaire to Beckett and Beyond* (New York, 2008), 58.

7. George Bernard Shaw, *The Doctor's Dilemma: A Tragedy* (1909), act 4, from the last speech of Louis Dubedat.

8. Margherita Sarfatti, quoted in Emily Braun, *Mario Sironi and Italian Modernism: Art and Politics Under Fascism* (New York, 2000), 92.

9. Cited in Richard Ellmann, *Oscar Wilde* (London, 1987), 201–202.

10. William Butler Yeats, *The Trembling of the Veil* (1922), in *Autobiography of William Butler Yeats* (New York, 1965), 93.

11. Oscar Wilde, "The Soul of Man Under Socialism" (1891), in *The Collected Works of Oscar Wilde,* ed. Robert Ross (1969), 1046.

12. Wilde quoted in Ellmann, *Oscar Wilde,* 581.

13. Ada Leverson, quoted ibid., 469.

14. Wilde to H. C. Marillier (December 12, 1885), in *The Complete Letters of Oscar Wilde,* ed. Merlin Holland and Rupert Hart-Davis (1962; New York, 2000), 272.

15. Wilde, "Note" in the New York Public Library, Berg Collection, quoted in Ellmann, *Oscar Wilde,* 310.

16. Yeats, *Trembling of the Veil,* 90.

17. Cited in Lawrence Danson, *Wilde's Intentions: The Artist in His Criticism* (Oxford, 1997), 107.

18. Ellmann, *Oscar Wilde,* 431.

19. *St. James's Gazette,* editorial, May 27, 1895.

20. Oscar Wilde, *The Picture of Dorian Gray* (London, 1891), vii.

21. Arthur Schnitzler, *Tagebücher,* 10 vols., ed. Peter Michael Braunwarth et al. (Vienna, 1981–2000). Quotations from *Tagebuch* 3 (December 21, 1908), 375, and *Tagebuch* 4 (April 4, 1912), 321.

22. Ibid., *Tagebuch* 5 (February 8, 1913), 17.

23. Letters from Mary Cassatt to Louisine Havemeyer, September 6 and October 2, 1912, and March 12, 1913, quoted in Frances Weitzenhoffer, *The Havemeyers: Impressionism Comes to America* (New York, 1986), 207, 208, 210.

CHAPTER FIVE: THE BEETHOVEN DECADES

1. E. T. A. Hoffmann, "Sinfonie pour . . . composée et dédiée etc par Louis van Beethoven," in *Allgemeine musikalische Zeitung* 12, nos. 40–41 (July 4 and 11, 1810), in *E. T. A. Hoffmanns Werke,* 15 vols., ed. Georg Ellinger, ed. (Berlin, 1912–1920), 13: 41–42.

2. Alfred Lichtwark, "Publikum" (1881), in *Erziehung des Auges: Ausgewählte Schriften,* ed. Eckhard Schaar (Frankfurt am Main, 1991), 25.

3. Ibid., 26.

4. Anonymous contemporary contributor to *Freimüthiges Abendblatt,* cited in *Thayer's Life of Beethoven,* 376.

5. Ibid., 363–429, passim.

EPILOGUE

1. Giorgio de Chirico, *Valori plastici* (1919), in *Metaphysical Art,* ed. Massimo Carrà et al. (New York, 1971), 91.

2. Vasili Kandinsky, *Das Sturm Album* (Berlin, 1913), xv.

3. Letter from Wassily Kandinsky to Will Grohmann, dated November 21, 1925, in Hans K. Roethel with Jean K. Benjamin, *Kandinsky* (1977; New York, 1979), 116.

4. Kazimir Malevich, *Die gegenstandslose, Welt* [The nonobjective world] (Berlin, 1927), passim.

5. Personal communication from Robert Motherwell.

6. See Gotthard Jedlicka, "Max Beckmann in seinen Selbstbildnissen," in *Blick auf Beckmann: Dokumente und Vorträge,* ed. Hans Martin Freiherr von Erffa and Erhard Göpel (Munich, 1962), 112.

bibliography

Abrams, Meyer Howard. *The Mirror and the Lamp: Theory and the Critical Tradition.* New York, 1953.

————. *Natural Supernaturalism: Tradition and Revolution in Romantic Literature.* New York, 1971. Two important titles in the history of romanticisms.

Barzun, Jacques. *Classic, Romantic, Modern.* New York, 1956.

Bate, Walter J. *From Classic to Romantic: Premises of Taste in Eighteenth-Century England.* Cambridge, MA, 1946.

————. *Negative Capability.* Cambridge, MA, 1939. Two justly influential treatises.

Behler, Ernst. *German Romantic Literary Theory.* New York, 1993.

Bénichou, Paul. *Romantismes français,* 2 vols. Paris, 2004.

Berend, Eduard. *Jean Pauls Aesthetik.* Berlin, 1909.

Berlin, Isaiah. "The Counter-Enlightenment." In *Against the Current: Essays in the History of Ideas,* 1–24. New York, 1979.

Bertaut, Jules. *L'Époque romantique.* Paris, 1947.

Blackall, Eric A. *The Novels of the German Romantics.* Ithaca, NY, 1983. A pioneering essay.

Blanning, T. C. W. *The Romantic Revolution: A History*. New York, 2011.

Börsch-Supan, Helmut, and Karl Wilhelm Jähnig, eds. *Caspar David Friedrich*. Munich, 1973. An exhaustive catalogue of Friedrich's oeuvre.

Breckman, Warren, ed. *European Romanticism: A Brief History with Documents*. Boston, 2008.

Brown, Marshall. *The Shape of German Romanticism*. Ithaca, NY, 1979. A useful, eclectic anthology of texts with commentary.

Butler, Marilyn. *Romantics, Rebels, and Reactionaries: English Literature and Its Background, 1760–1830*. New York, 1982. A brilliant, wide-ranging survey from which I have benefited.

Cassirer, Ernst. *Rousseau, Kant, Goethe: Two Essays*. Princeton, 1945.

Charlton, D. G., ed. *The French Romantics,* 2 vols. Cambridge, 1984. A fine gathering of substantial essays including the arts.

Chateaubriand, François René, Vicomte de. *Génie du Christianisme,* 2 vols. 1802. The contemporary masterpiece of Christian apologetics.

Clark, Kenneth. *The Romantic Rebellion: Romantic Versus Classic Art*. New York, 1973.

Cruickshank, John. *Benjamin Constant*. New York, 1974.

Curran, Stuart. *The Cambridge Companion to British Romanticism,* 2nd ed. Cambridge, 2010.

Dahlhaus, Carl. *Nineteenth-Century Music,* trans. from the German by J. Bradford Robinson. Berkeley, 1989.

Dollot, René. *Stendhal, journaliste*. Paris, 1948.

Forbes, Elliot, ed. and rev. *Thayer's Life of Beethoven*. Princeton, 1967, 1974. *The* biography.

Fricke, Gerhard. *Bemerkungen zu Wilhelm Heinrich Wackenroders Religion der Kunst.* In *Festschrift für Paul Kluckhohn und Hermann Schneider*. Tübingen, 1948.

Gadney, Reg. *Constable and His World*. New York, 1976.

Gage, John. *Color in Turner: Poetry and Truth*. New York, 1969.

———. *Turner: Rain, Steam, and Speed*. London, 1972. Two significant monographs.

Gaull, Marilyn. *English Romanticism: The Human Context*. New York, 1988. A helpful effort to integrate English romantics in social history.

Gibelin, Jean. *L'Esthétique de Schelling d'après la philosophie de l'art*. Paris, 1934.

Gillot, Hubert. *Chateaubriand, ses idées—son action—son oeuvre*. Paris, 1934.

Greig, James, A. *Francis Jeffrey of the Edinburgh Review*. Edinburgh, 1948. A warm tribute to the editor of a powerful periodical during the romantic period.

Gundolf, Friedrich. *Romantiker*. Berlin, 1930.

Guyer, Byron. "Francis Jeffrey's Essay on Beauty." *Huntington Library Quarterly* 13 (November 1949), 71–85.

Hoffmann, Werner, ed. *Caspar David Friedrich, 1774–1840*. Munich, 1974. A richly illustrated catalogue that does not neglect Friedrich's fellow German artists.

Izenberg, Gerald. *Impossible Individuality: Romanticism, Revolution, and the Origins of Modern Selfhood, 1787–1802*. Princeton, 1992.

Körner, Josef, ed. *Briefe von und an August Wilhelm Schlegel*, 2 vols. Zurich, 1930.

Levin, Harry. *Toward Stendhal*. Murray, UT, 1945. Justly praised by Wellek as "a fine general essay."

Lovejoy, Arthur O. *Essays in the History of Ideas*. Baltimore, 1948. This volume contains the key essay of the author's skepticism on romanticism as a unified historical stage, "On the Discrimination of Romanticisms" (1924), as well as other papers relevant to the present volume, notably "The Meaning of 'Romantic' in Early German Romanticism" (1916) and "Schiller and the Genesis of German Romanticism" (1920).

————. *The Great Chain of Being: A Study in the History of an Idea.* Cambridge, MA, 1936, chapter 10.

March, Florence. *Wordsworth's Imagery: A Study in Poetic Vision.* New Haven, 1952.

Micale, Mark S. "Romanticism." In *Europe 1789–1914,* 5 vols., ed. John Merriman and Jay Winter, 4: 2026–2033. New York, 2006.

Miles, Josephine. *Pathetic Fallacy in the Nineteenth Century: A Study of a Changing Relation Between Object and Emotion.* Berkeley, 1942.

Minor, Jacob, ed. with commentary. *Friedrich Schlegel, 1794–1802; seine prosaischen Jugendschriften,* 2 vols. Vienna, 1882.

Neubauer, John. *Novalis.* Boston, 1980.

Paz, Mario. *The Romantic Agony,* 2nd ed., trans. from the Italian by Angus Davidson. London, 1970.

Peyre, Henri. *What Is Romanticism?* trans. from the French by Roda Roberts. Tuscaloosa, AL, 1977.

Porter, Roy, and Mikuláš Teich. *Romanticism in National Context.* Cambridge, 1988.

Rehder, Helmut. "Novalis and Shakespeare." *PMLA* 63 (June 1948), 604–624.

Reynolds, Graham. *Constable, the Natural Painter.* New York, 1965.

Rosen, Charles. *The Romantic Generation.* Cambridge, MA, 1995.

Rossé, Charles-Albert. *Les théories littéraires de Victor Hugo.* Paris, 1903.

Rouge, Isaac. *Frédéric Schlegel et la genèse du romantisme allemand (1791–1797).* Paris, 1904. A relatively rare French contribution to German scholarship.

Schenk, Hans G. *The Mind of the European Romantics: An Essay in Cultural History.* Oxford, 1979.

Walzel, Oskar Franz. *Friedrich Schlegels Briefe an seinen Bruder August Wilhelm.* Berlin, 1890. A very significant collection.

————. *Romantisches*. Bonn, 1934. An important essay.

Watson, J. R. *Picturesque Landscape and English Romantic Poetry*. London, 1970.

Wellek, René. *A History of Modern Criticism, 1750–1950,* vol. 2, *The Romantic Age*. New Haven, 1955.

————. *Immanuel Kant in England, 1793–1838*. Princeton, 1931.

Williamson, George S. *The Longing for Myth in Germany: Religion and Aesthetic Culture from Romanticism to Nietzsche*. Chicago, 2004.

Zilkowski, Theodore. *Clio the Romantic Muse: Historicizing the Faculties in Germany*. Ithaca, NY, 2004.

————. *German Romanticism and Its Institutions*. Princeton, 1990. Two valuable studies.

acknowledgments

This is by way of thanking four friends who did much to make this book a reality: Professor Mark Micale; Zenaida So (affectionately a.k.a. Zany); Dan Heaton, for some fine editing; and Ileene Smith, for starting it all.

index

Peter Gay was born in Berlin in 1923 and emigrated to the United States in 1941, an experience he describes in *My German Problem*. He is the author of more than twenty-five books, including the magisterial five-volume study *The Bourgeois Experience: Victoria to Freud* and the influential *Freud: A Life for Our Time*. Gay is Sterling Professor of History Emeritus at Yale University and was the first director of the New York Public Library's Center for Scholars and Writers. He has won two Guggenheim fellowships and received many awards for his writing, among them a National Book Award in 1967 and the American Historical Association's (AHA) Award for Scholarly Distinction in 2004.

romantic writers and artists in all media. Gay's scope is wide, his insights sharp. He takes on the recurring questions about how to interpret romantic figures and their works. Who qualifies to be a romantic? What ties together romantic figures who practice in different countries, employ different media, even live in different centuries? How is modernism indebted to romanticism, if at all? Guiding readers through the history of the romantic movement across Britain, France, Germany, and Switzerland, Gay argues that the best way to conceptualize romanticism is to accept its complicated nature and acknowledge that there is no 'single basket' to contain it. Gay conceives of romantics in 'families,' whose individual members share fundamental values but retain unique qualities. He concludes by demonstrating that romanticism extends well into the twentieth century, where its deep and lasting impact may be measured in the work of writers such as T. S. Eliot and Virginia Woolf."—Provided by publisher.

Includes bibliographical references and index.

ISBN 978-0-300-14429-1 (hardback)

1. Romanticism in art. I. Title.

NX454.5.R6G39 2015

700'.4145—dc23

2014012669

A catalogue record for this book is available from the British Library.

This paper meets the requirements of ANSI/NISO Z39.48-1992 (Permanence of Paper).

10 9 8 7 6 5 4 3 2 1